LONDON BLUES

TO MY LADIES
LYNNE AND JESSICA

London Blues

PHOTOGRAPHS BY NOBBY CLARK

rp

ROUPELL PRESS

LONDON

Published by Roupell Press, London in 2007

All photographs © copyright Nobby Clark 1967 to 2007

Contact Nobby Clark care of
Oberon Books Ltd, 521 Caledonian Road
London N7 9RH

nobby@nobbyclark.co.uk

ISBN 13: 978 1 84002 735 8
ISBN 10: 1 84002 735 5

Design by Dan Steward

Printed in Chippenham, Wilts by Antony Rowe Ltd

FOREWORD

I've known Nobby Clark as a theatre photographer
for more than thirty years – indeed I've known him
since he photographed, with great brilliance, the
production of *Tamburlaine the Great* with Albert
Finney which was one of the opening shows in the
Olivier Theatre. His pictures have continued to be
strong and dramatic. They have the knack of always
letting you know what the characters in the scene
are thinking. His instinct for making the shutter
click at precisely the right moment seems never to
have faltered.

This wonderful collection takes us into his other
life – almost his secret life. Nobby is a cockney to
his fingertips: he loves London. But his London is
peopled with surprises. The comedies, the tragedies
and the paradoxes of ordinary people are combined
with some pictures of extraordinary people to give
a stimulating record of London life. There is rich
humour here, allied to a record of contradiction.
Sad old buildings are dominated by a pulsing new
skyscraper. St Paul's itself (that constant image
of war-time survival) is upstaged by a burst of
fireworks.

Nobby has only to walk out into the street and place
his camera to the eye for us to be stimulated and
surprised. I wish we were all so richly endowed
– but at least he insists that we don't just look,
we SEE.

Peter Hall

SIR PETER HALL, FEBRUARY 2007

ACKNOWLEDGEMENTS

'Taking photos of my town – its people, buildings, the river…it changes every day. London is my Landscape.'

I am never without a small camera in my pocket. I take at least one photograph every day and this has allowed me to capture the streets and the people of London as I see and feel them.

This book is a record of 'London Blues', an exhibition of these 101 photographs of London, taken over forty years, which opened at the National Theatre in London on 6 February 2007.

I would like to thank the following people, without whose generosity and encouragement neither the exhibition nor the book would have been possible:

Hamilton Corporate Finance Limited
Bryan Murphy and Nigel Learmond
James Hogan of Oberon Books
Dan Steward for his cool design
Sir Peter Hall
The National Theatre
John Langley
Laura Hough
Dillon Bryden for his limitless patience
Jeff Taylor of Antony Rowe Ltd
Davide Mengoli of GX Gallery
Anthony Pye-Jeary
Dewynters
Process Supplies

NOBBY CLARK, FEBRUARY 2007

THE PHOTOGRAPHS

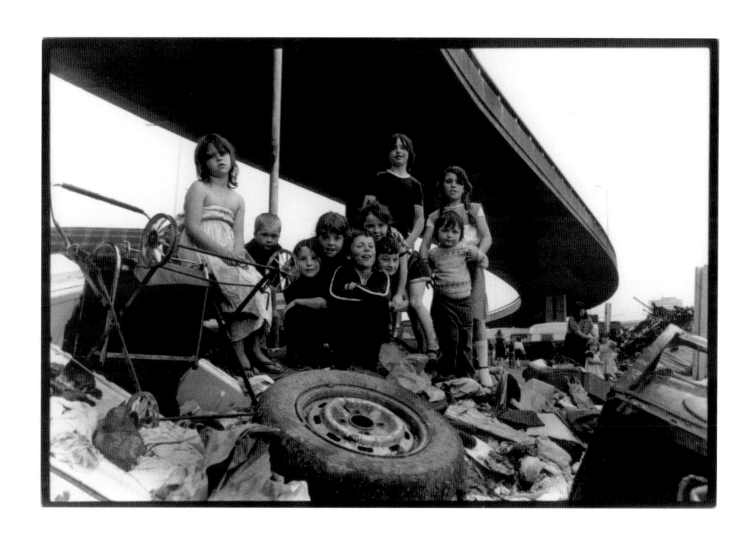

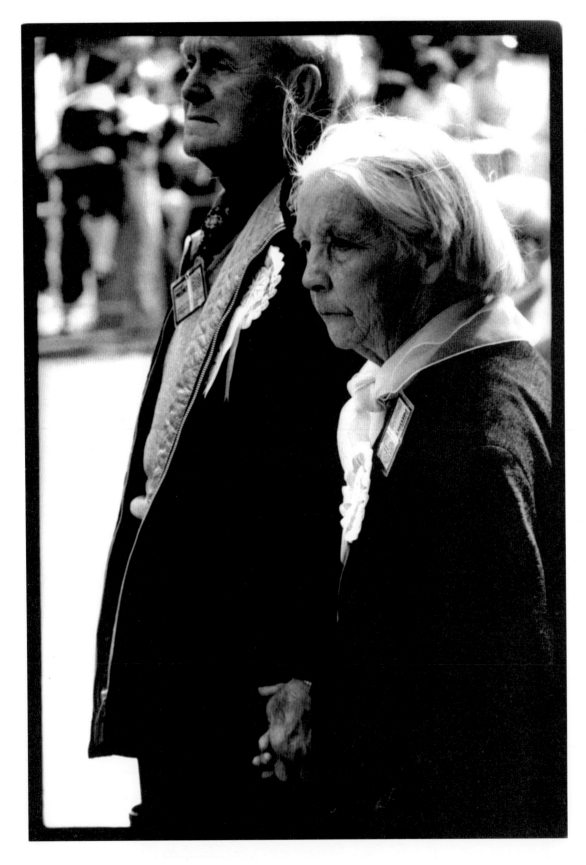

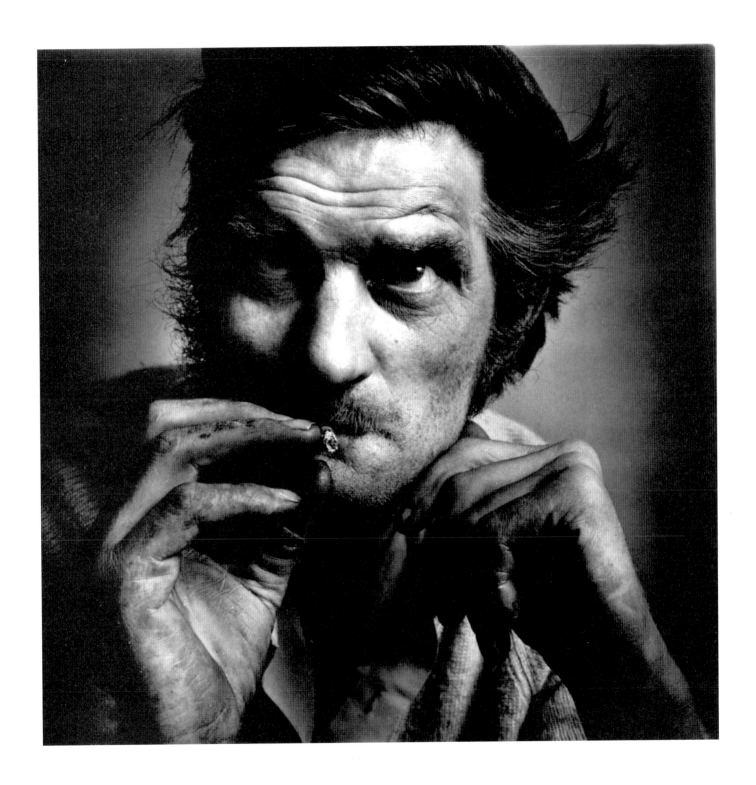

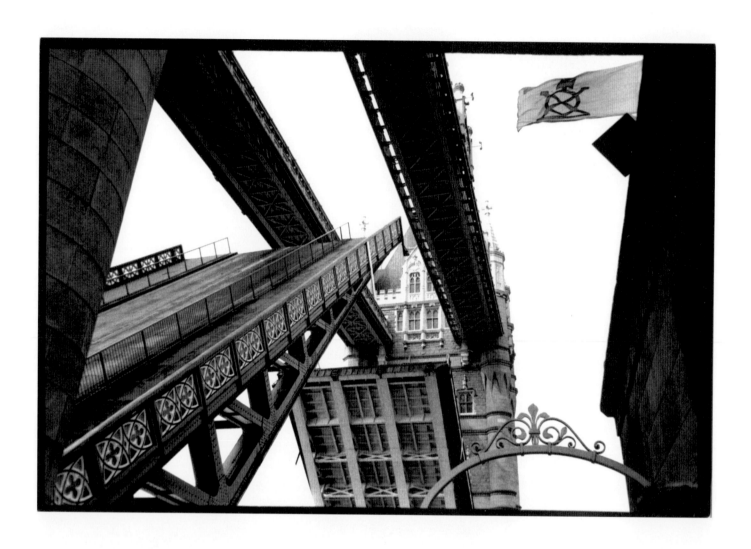

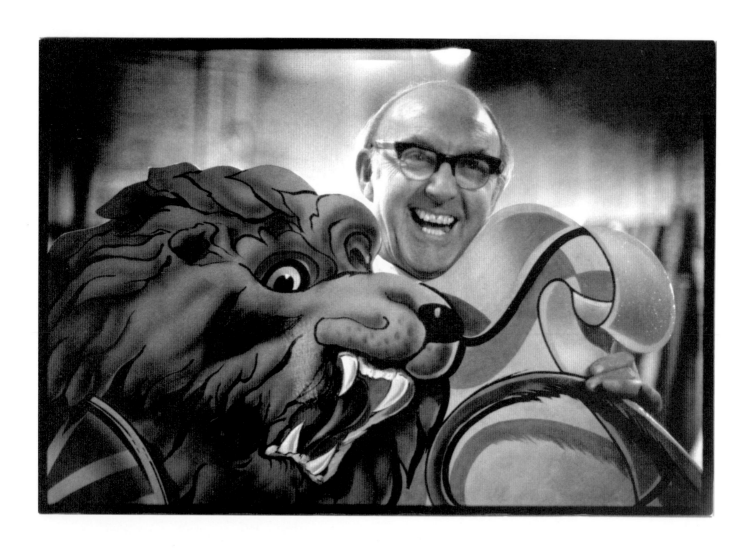

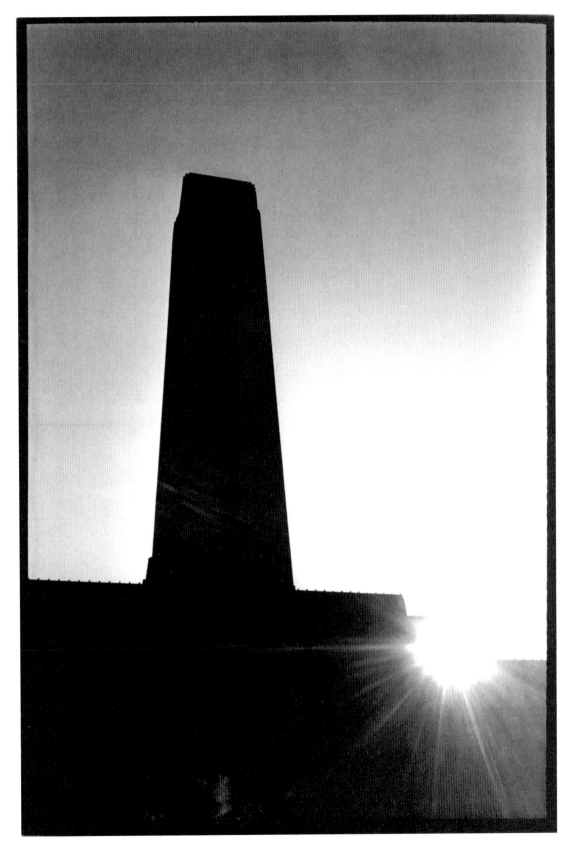

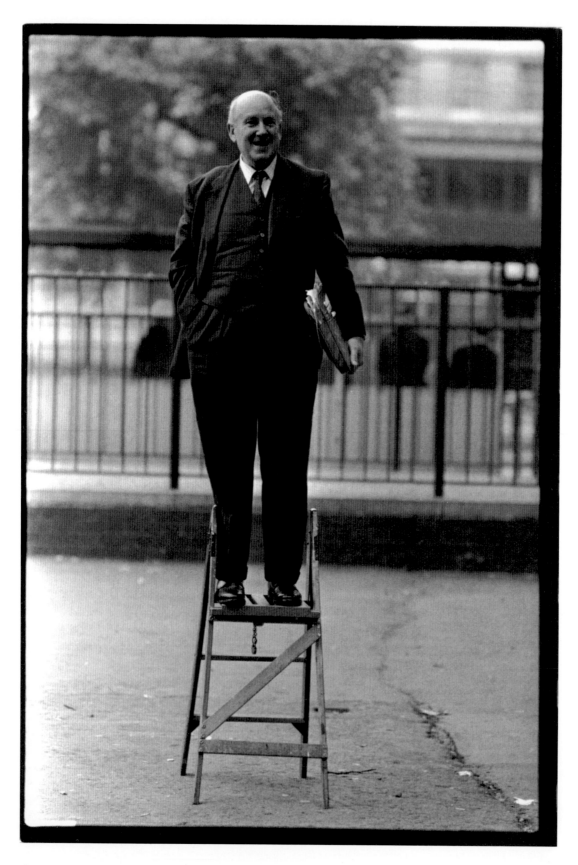

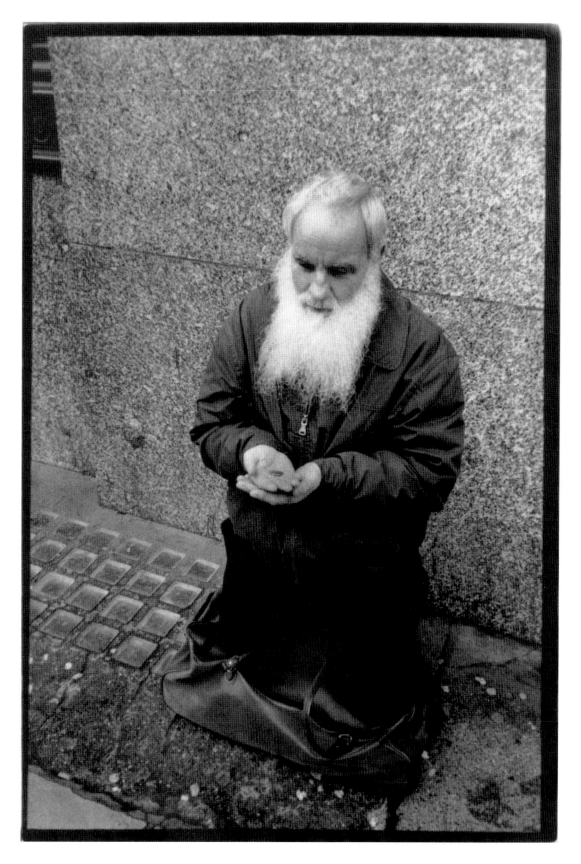

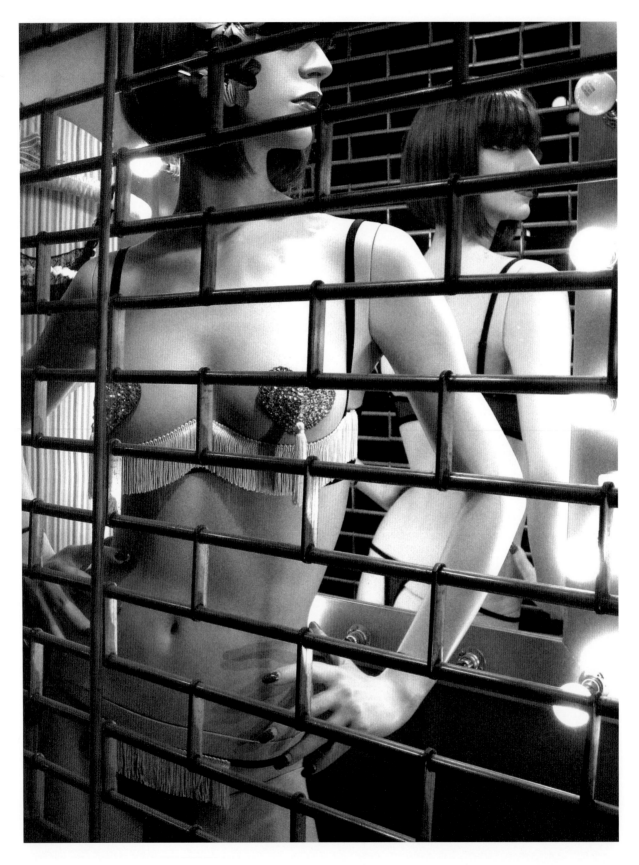

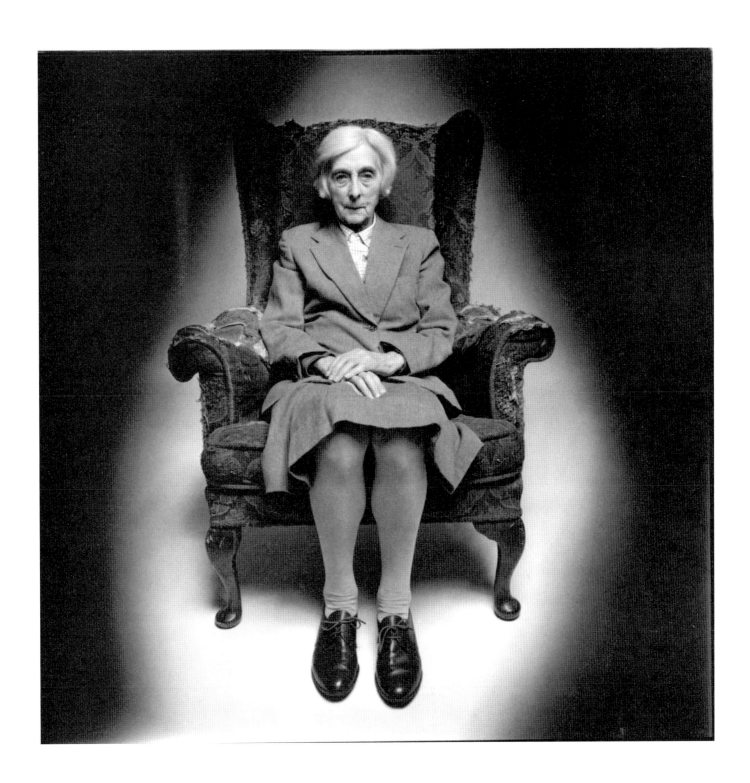

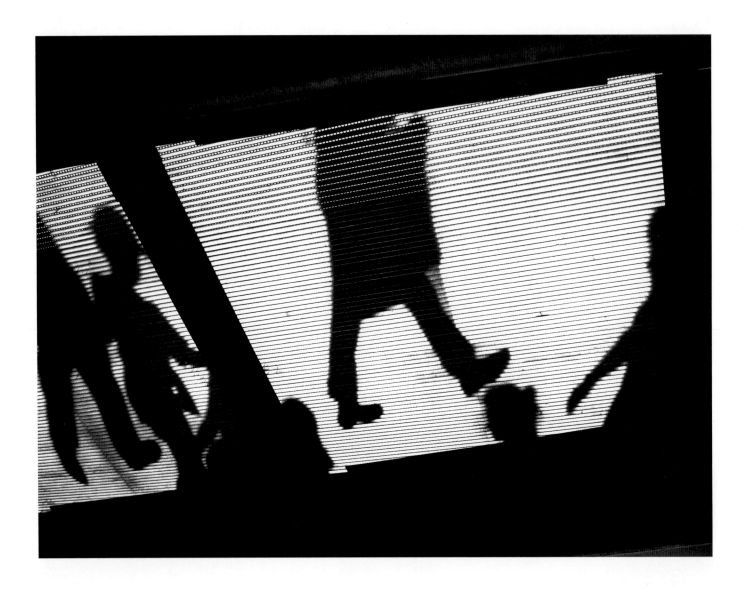

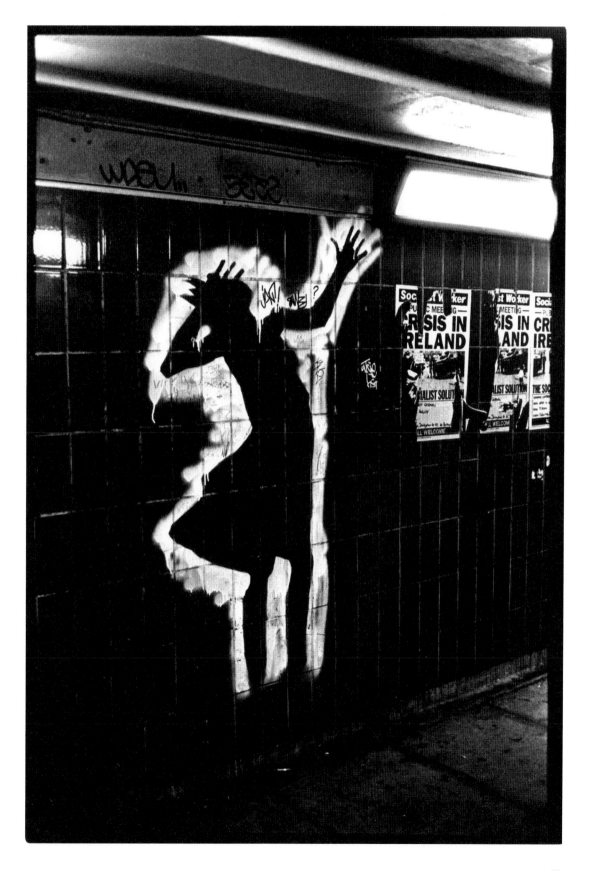

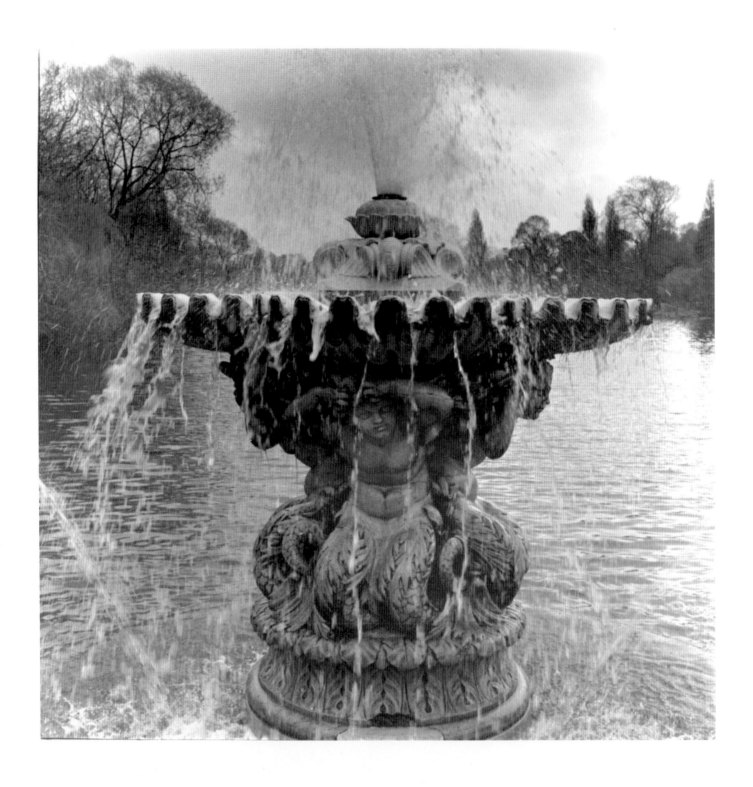

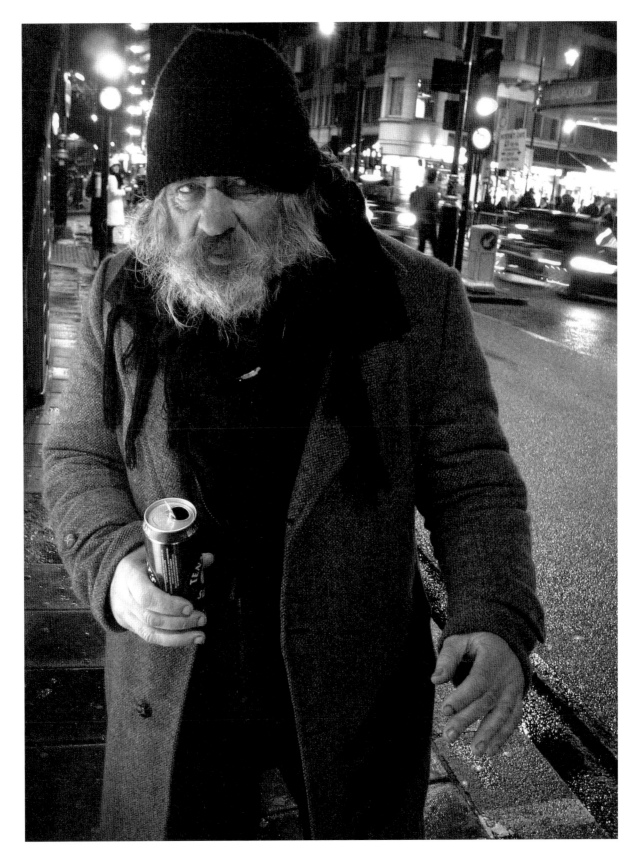

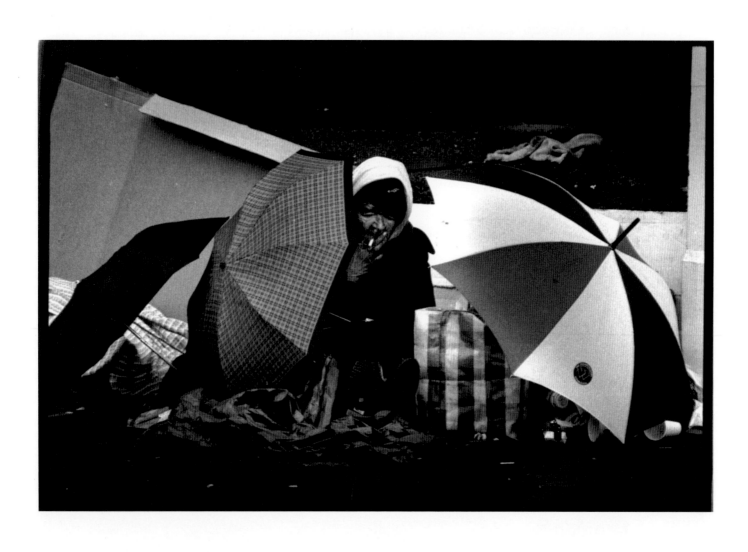

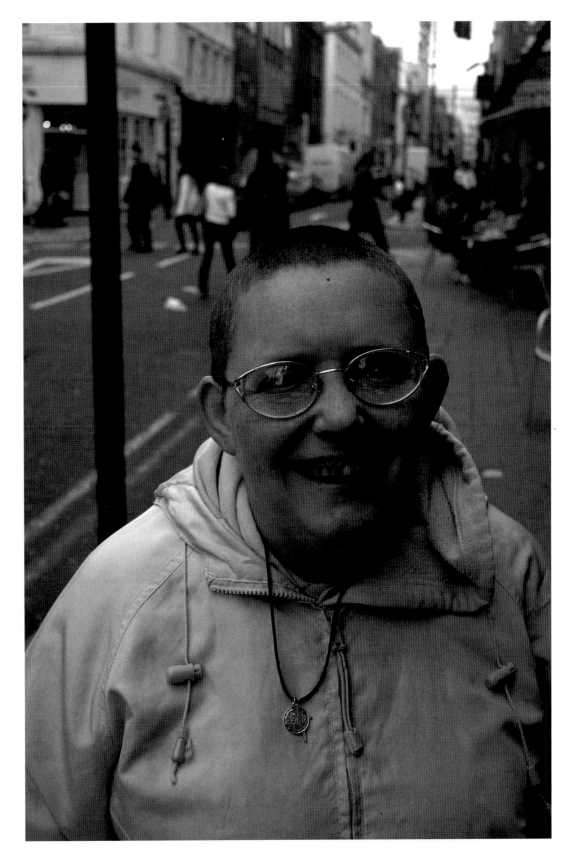

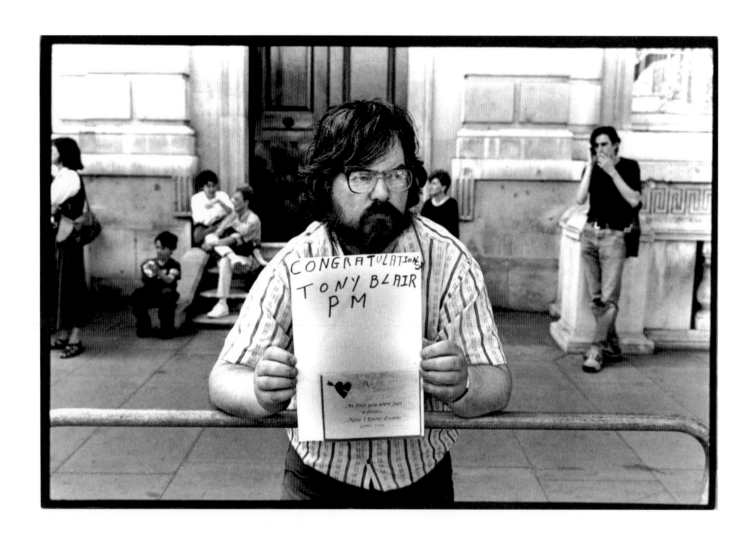

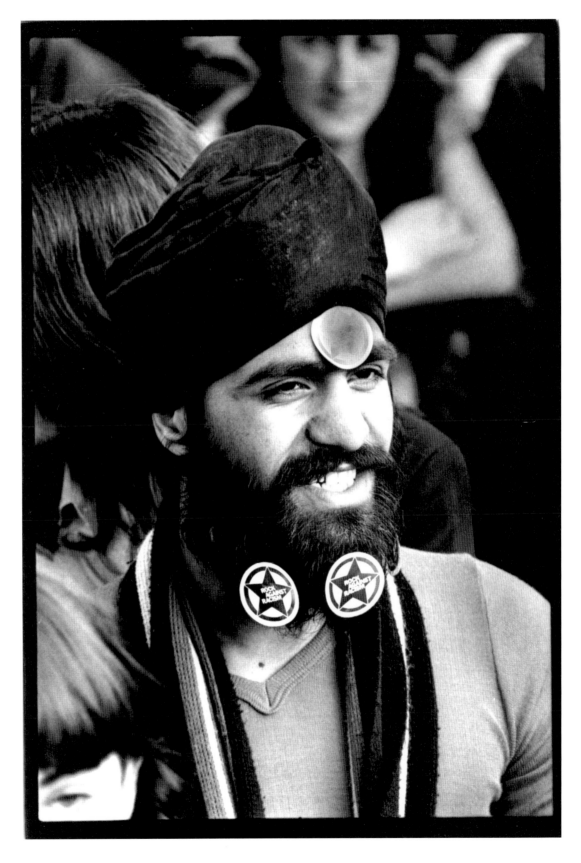

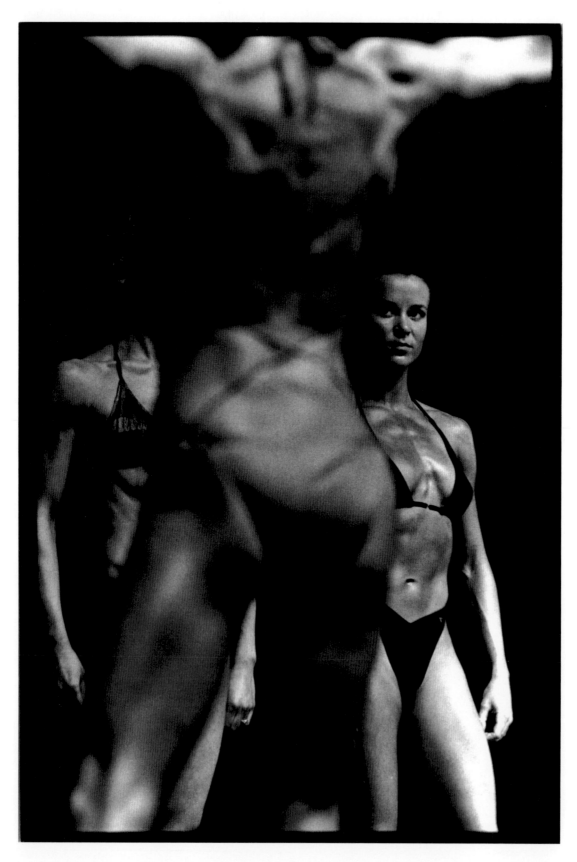

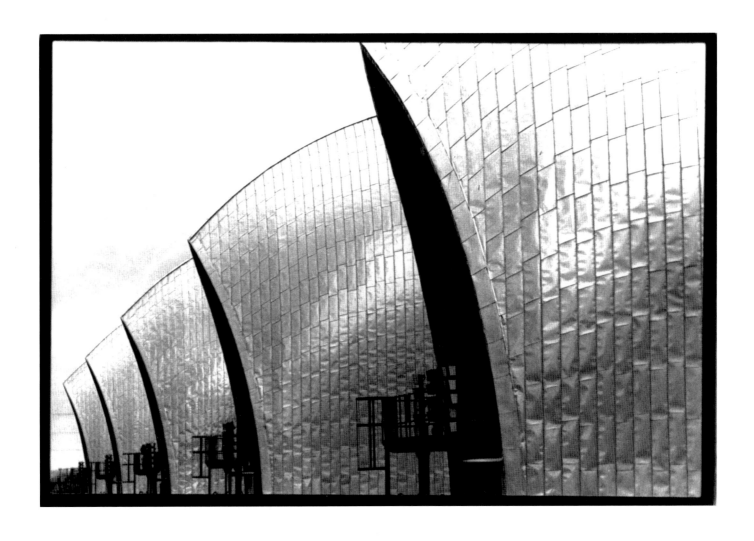

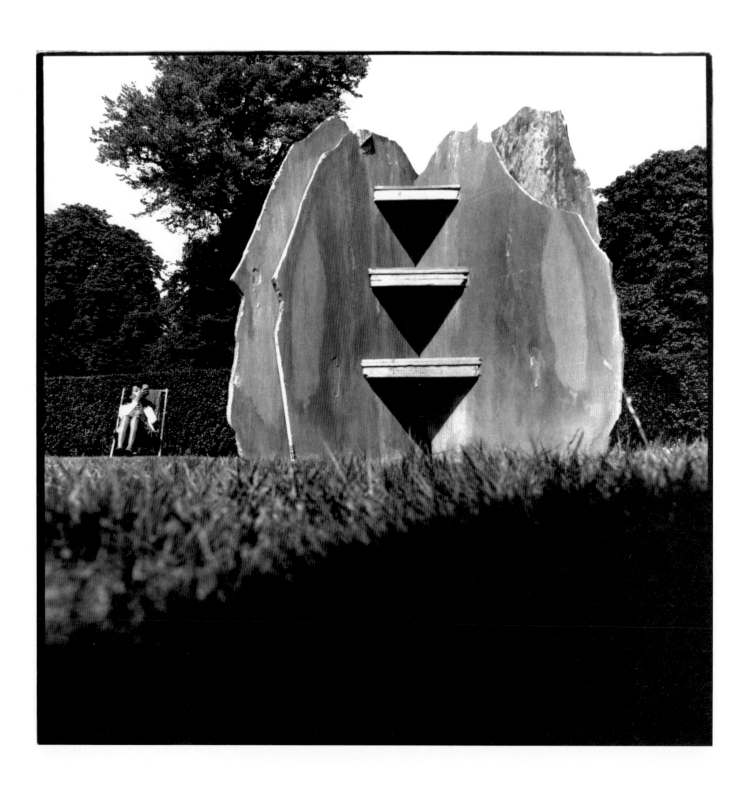

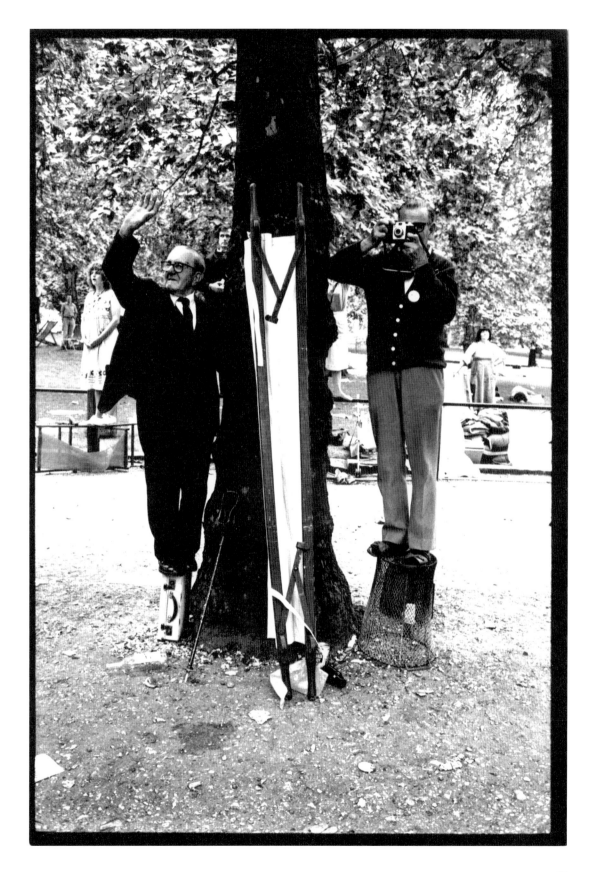

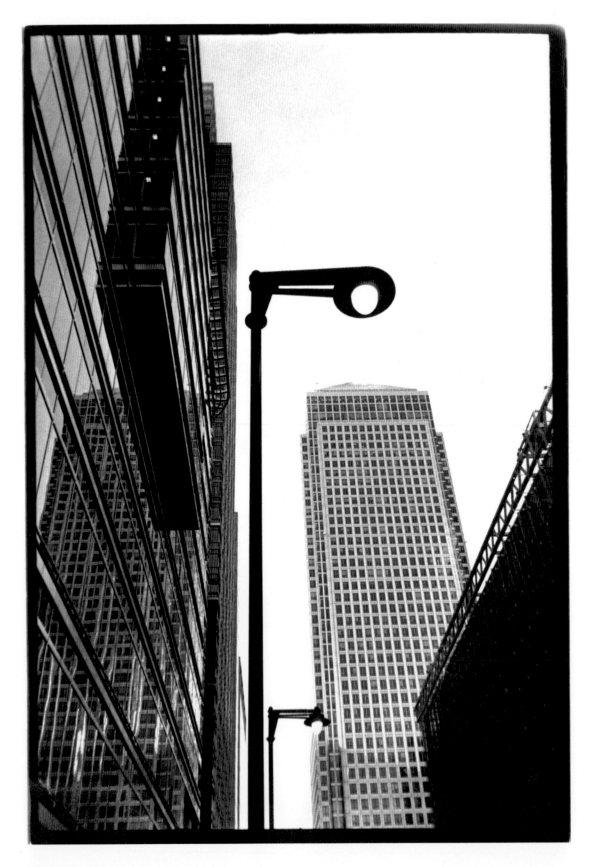

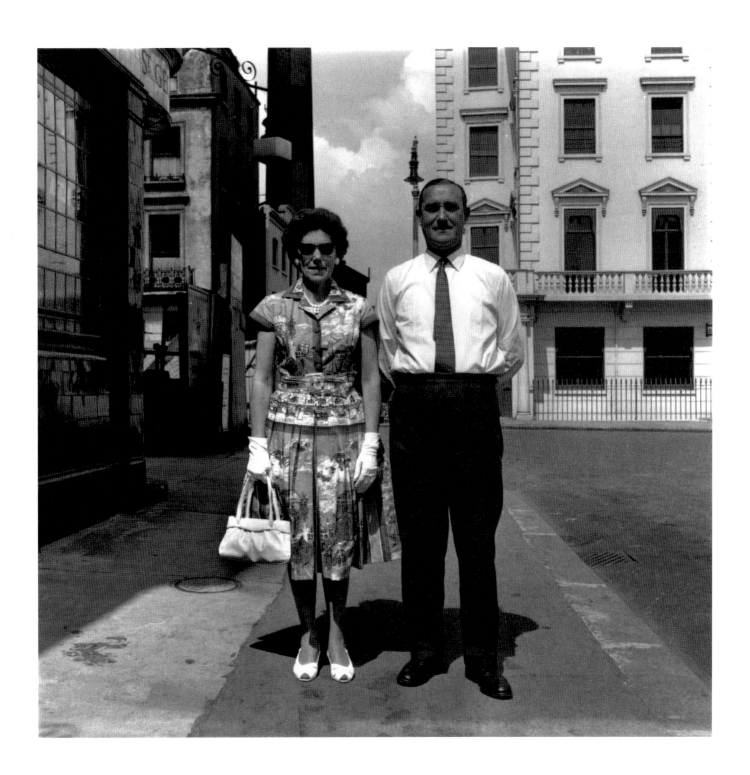

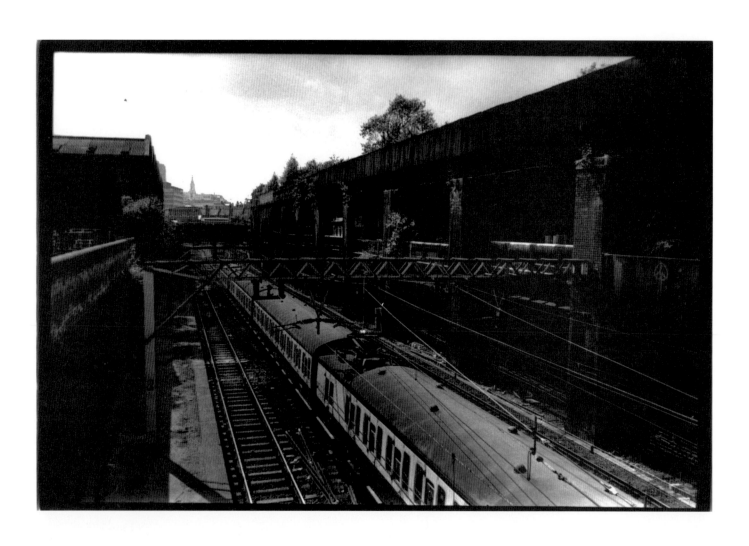

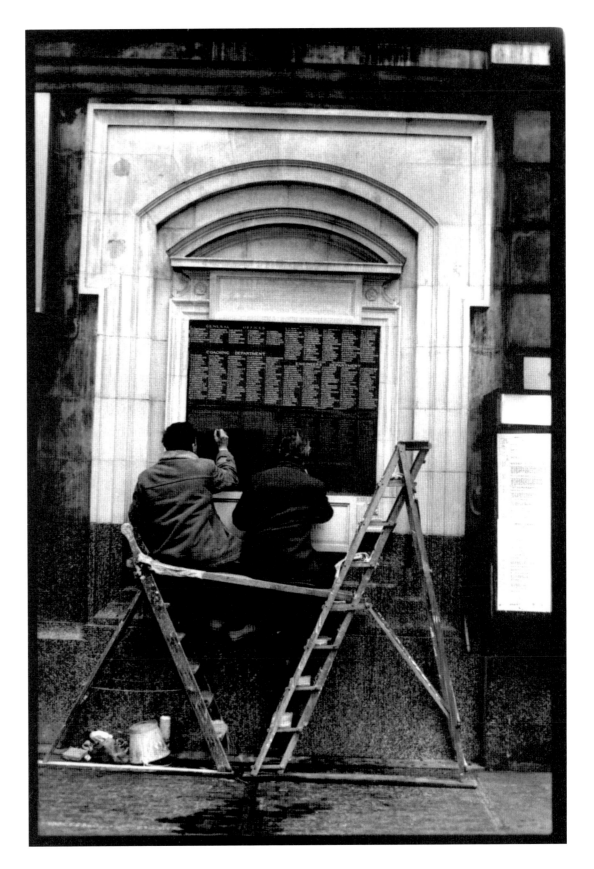

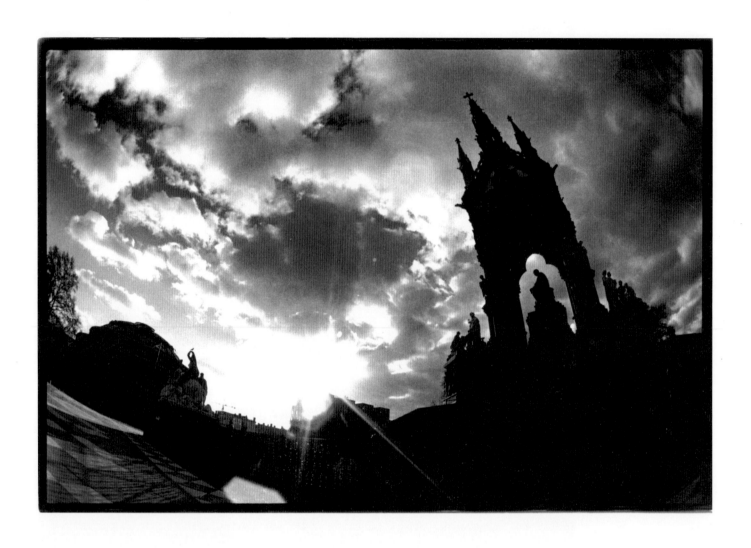

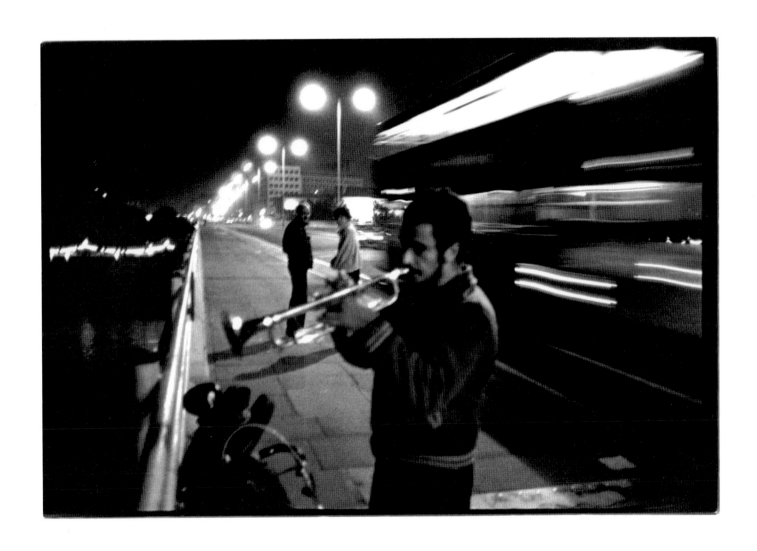

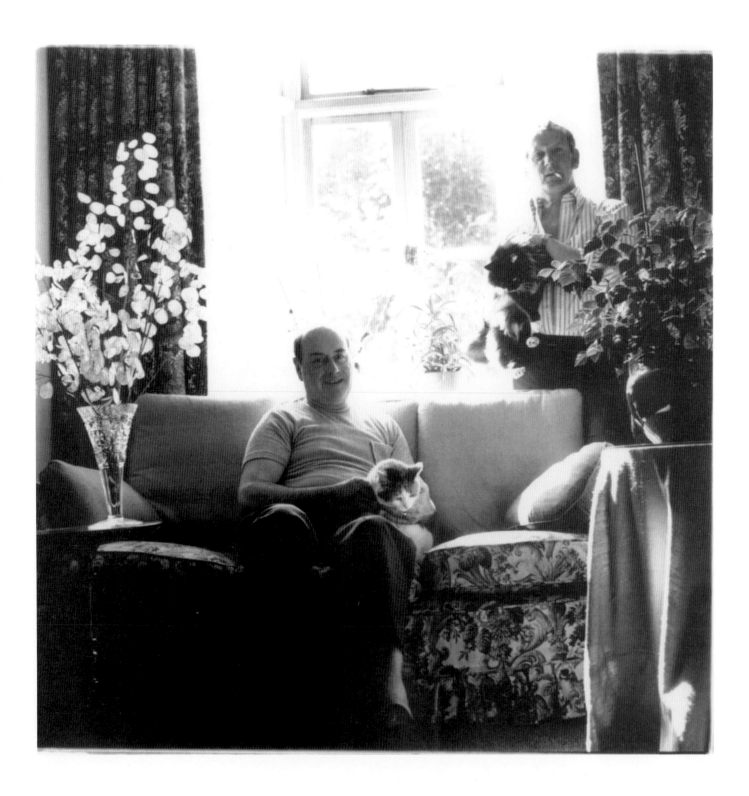

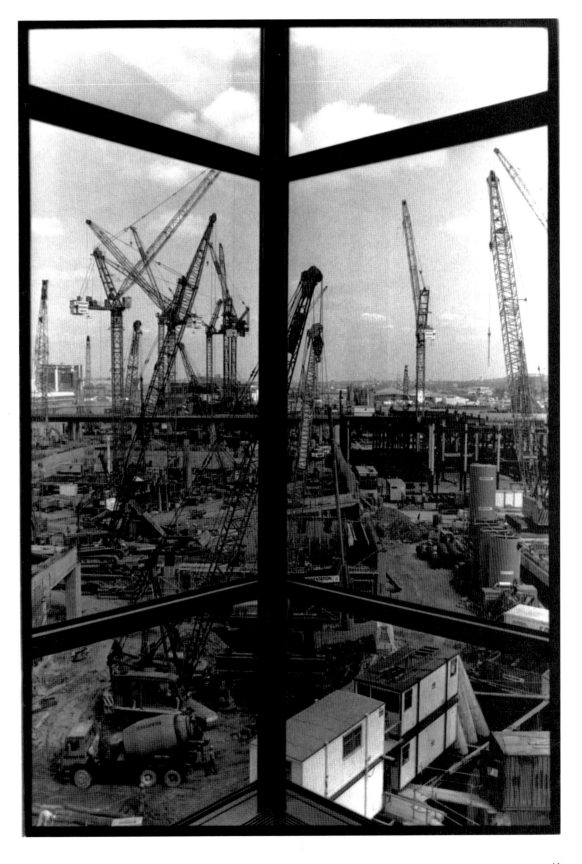

41

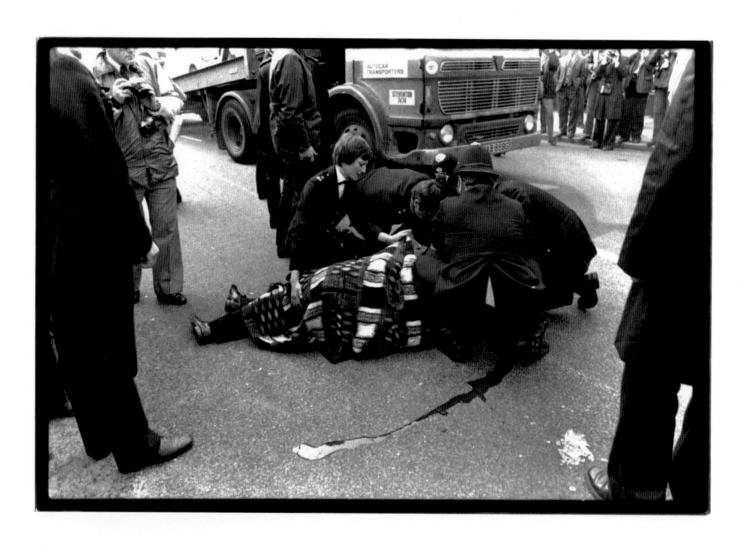

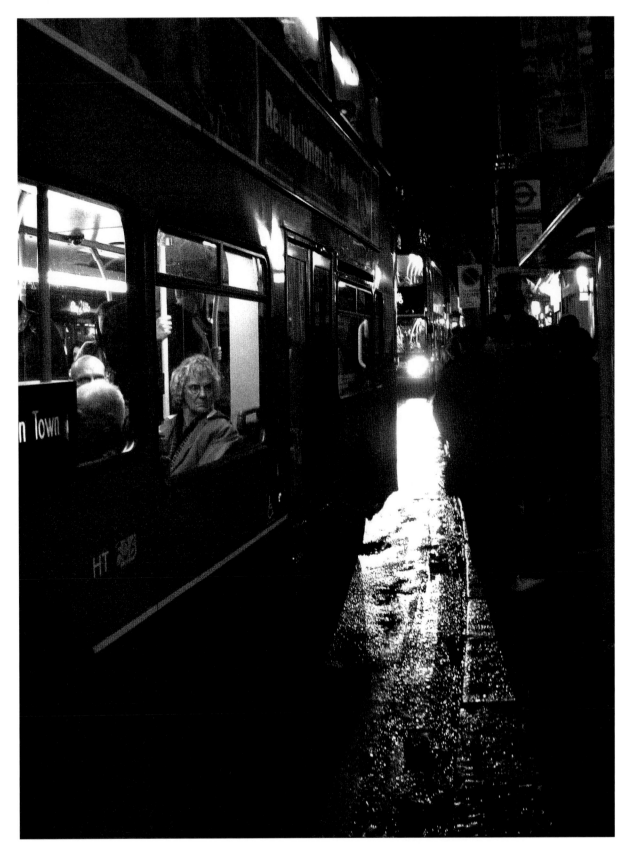

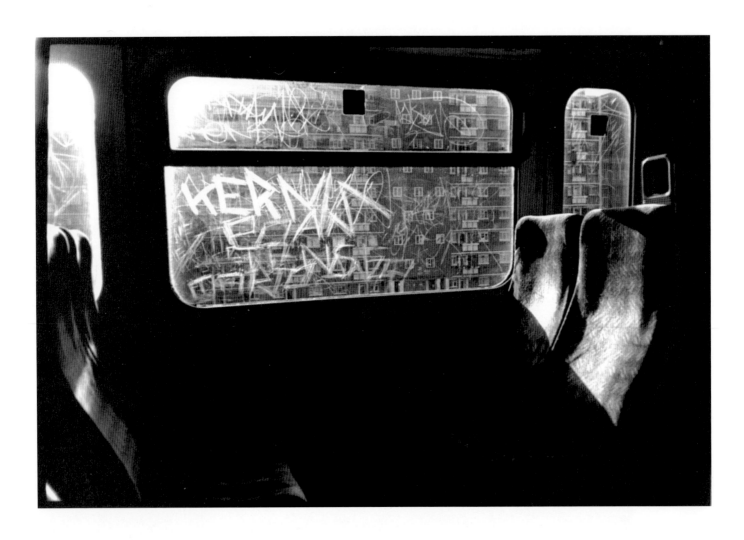

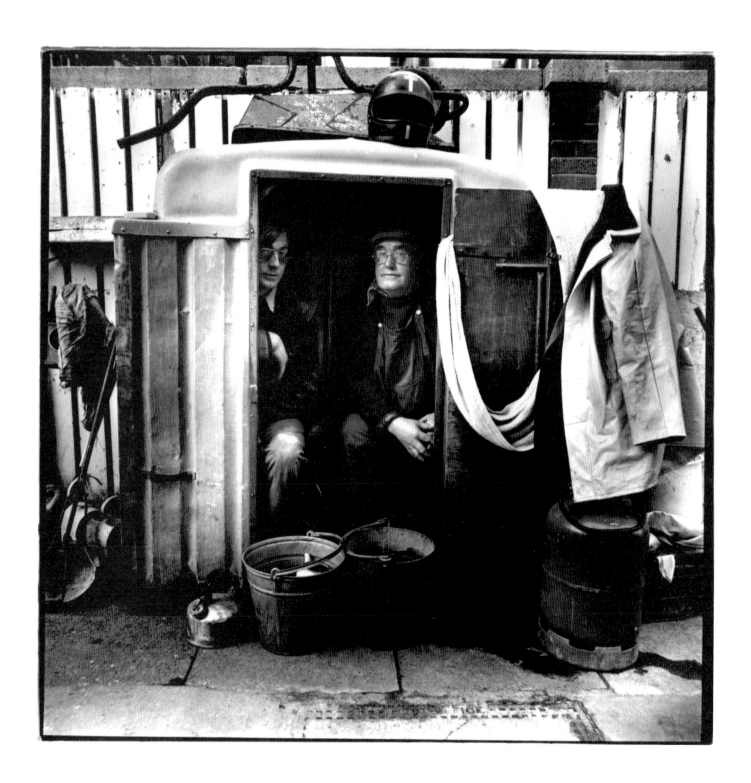

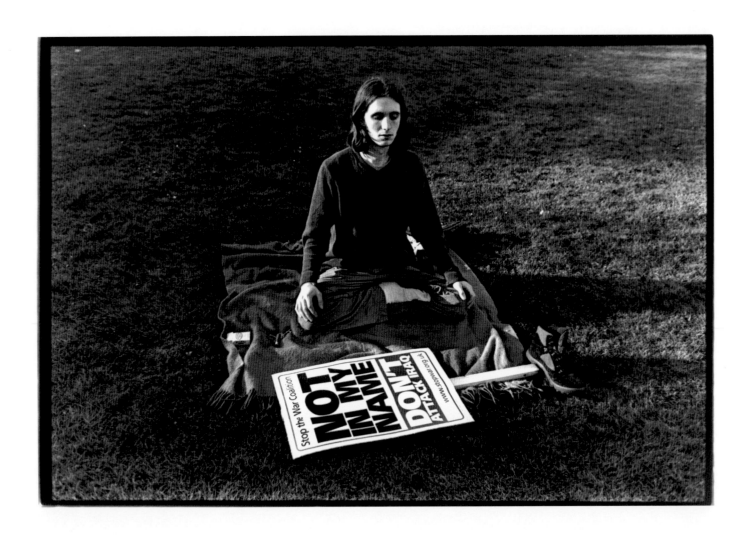

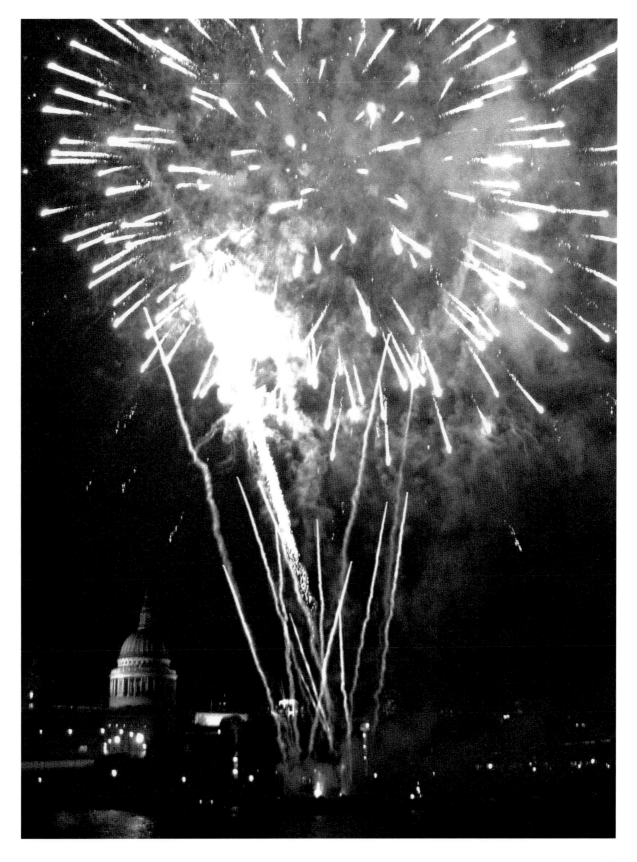

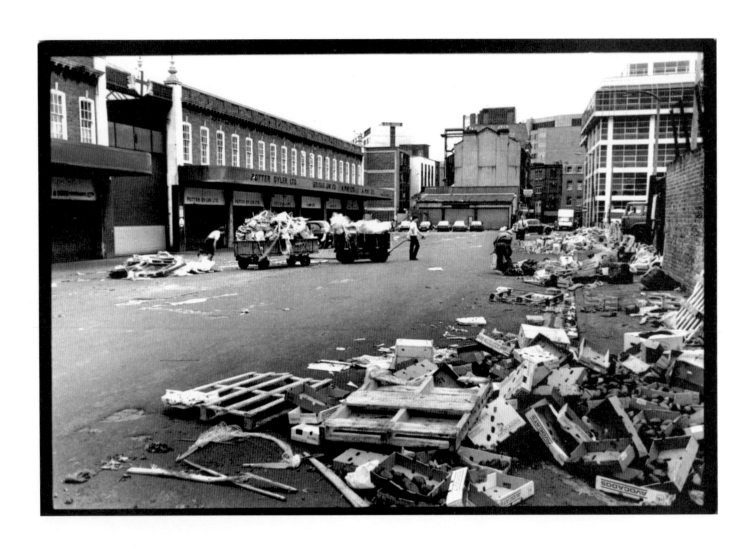

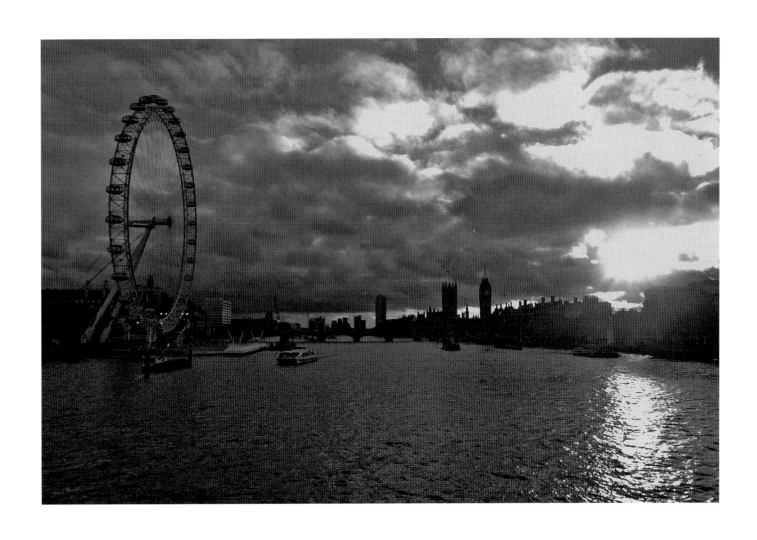

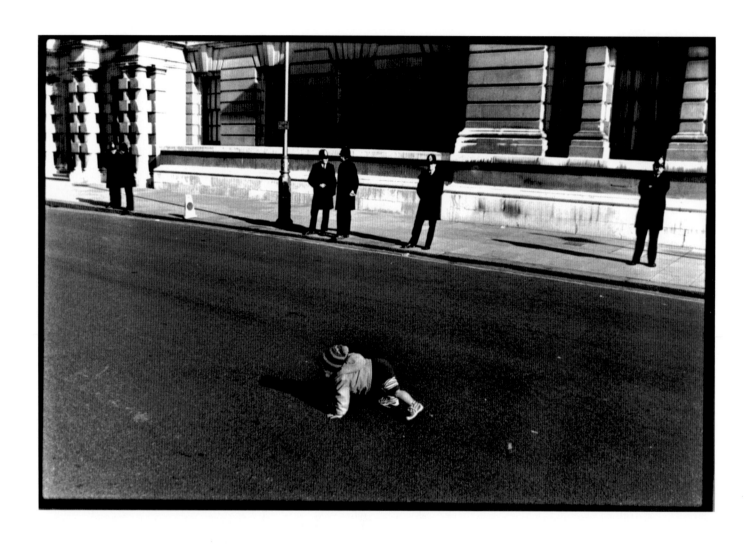

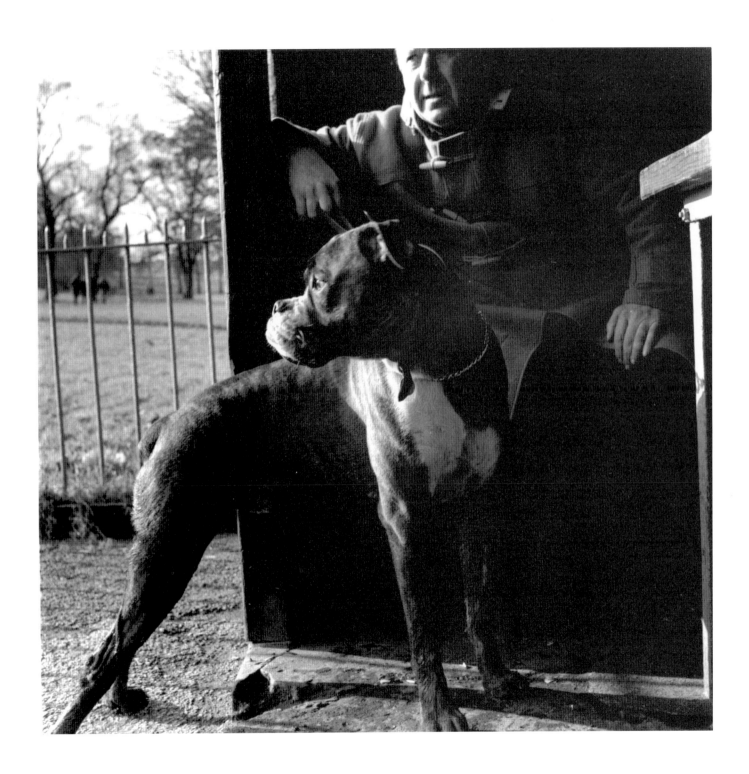

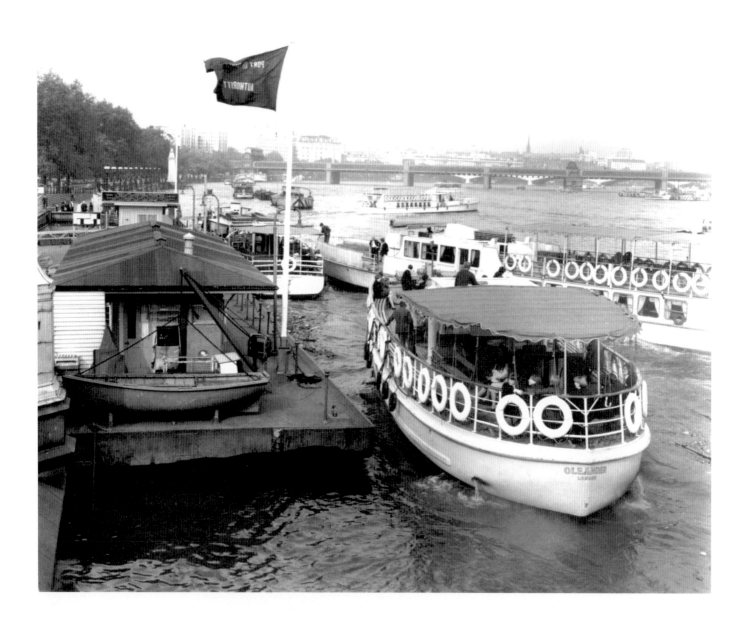

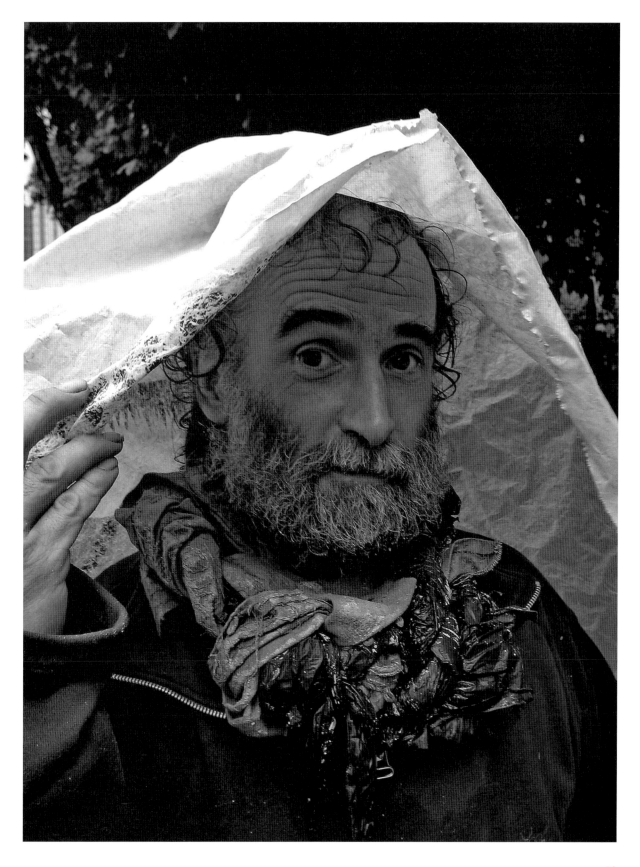

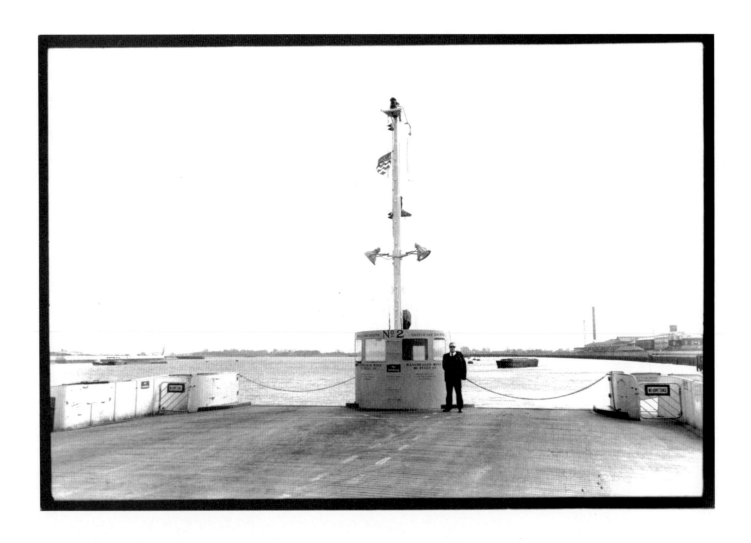

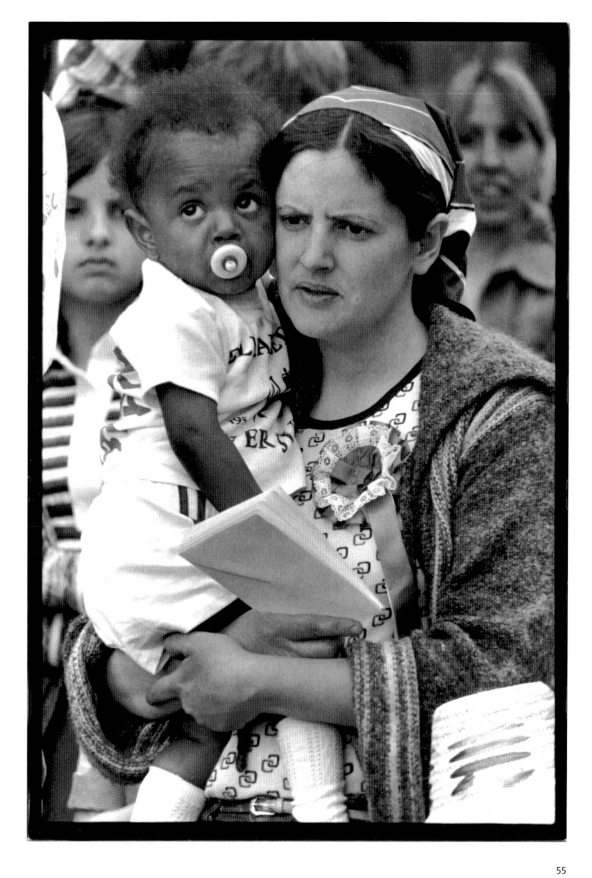

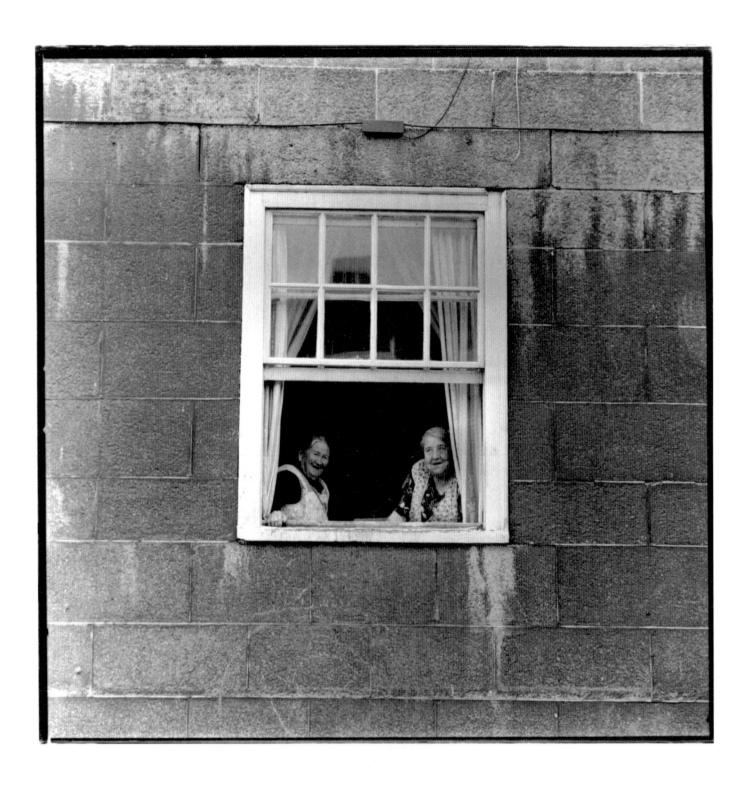

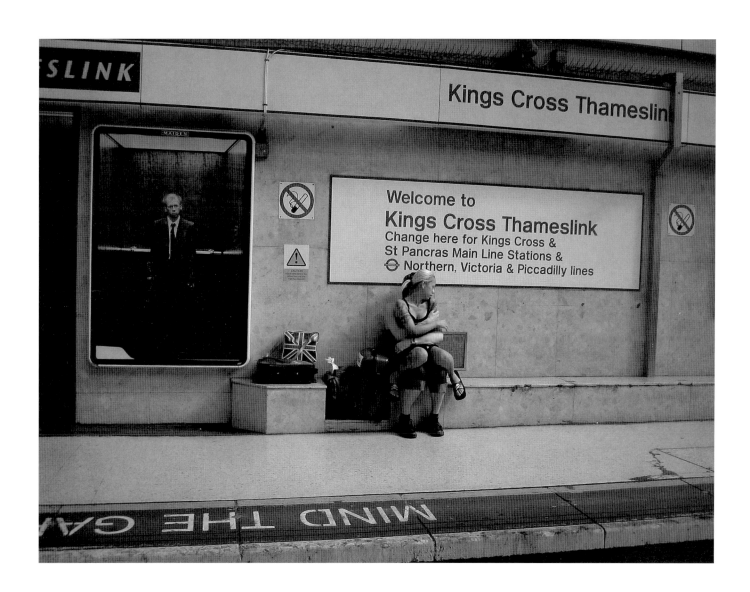

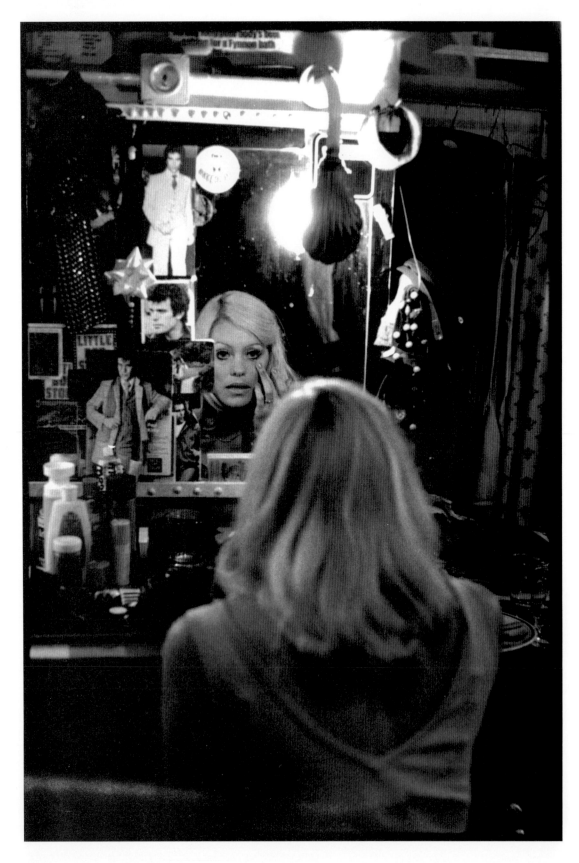

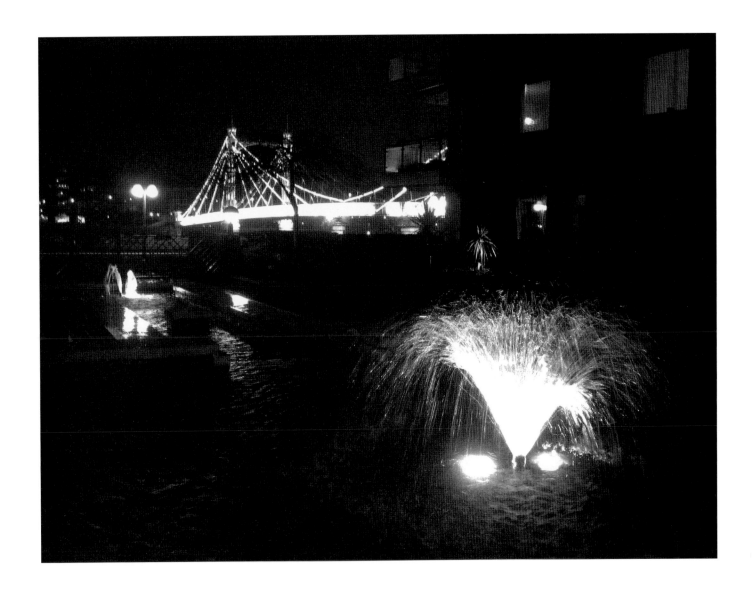

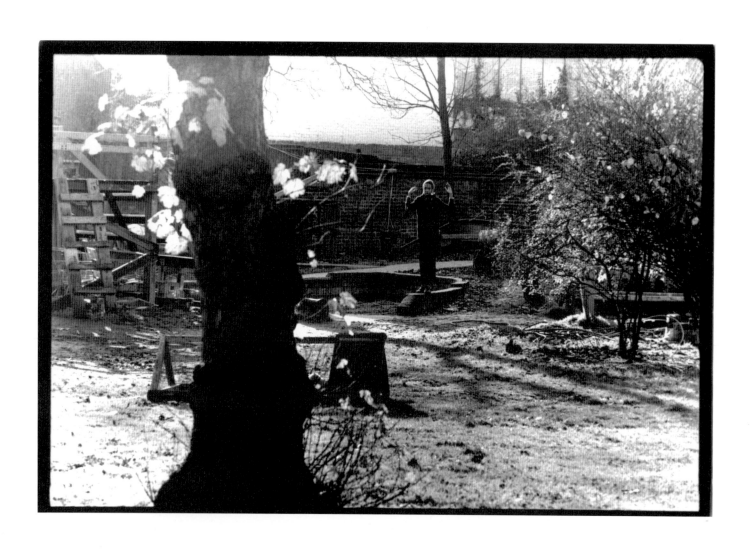

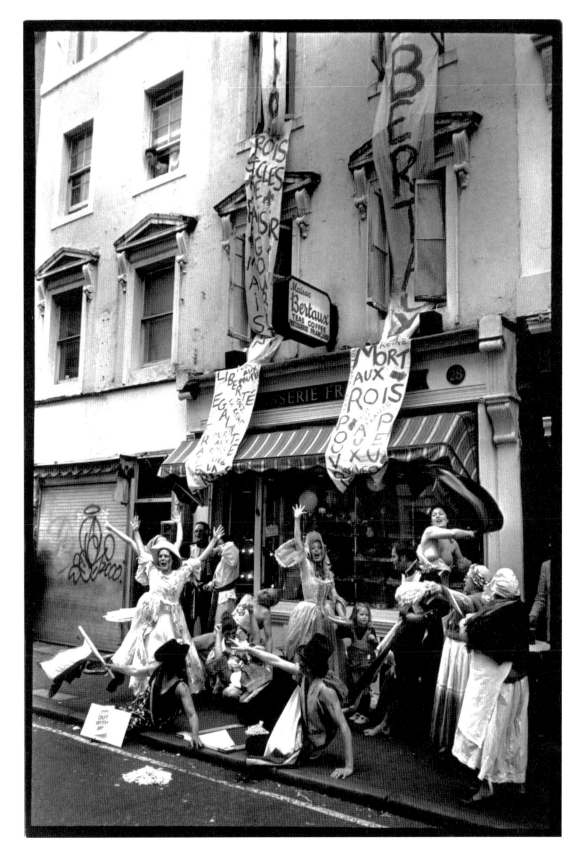

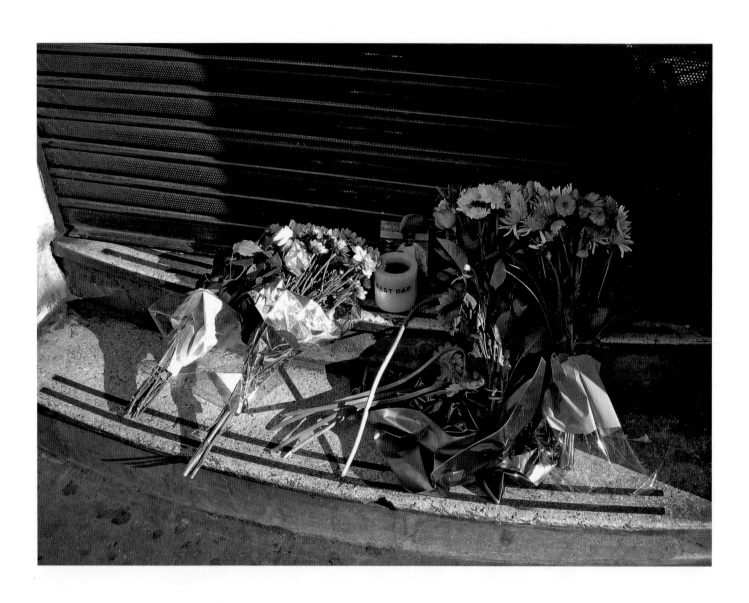

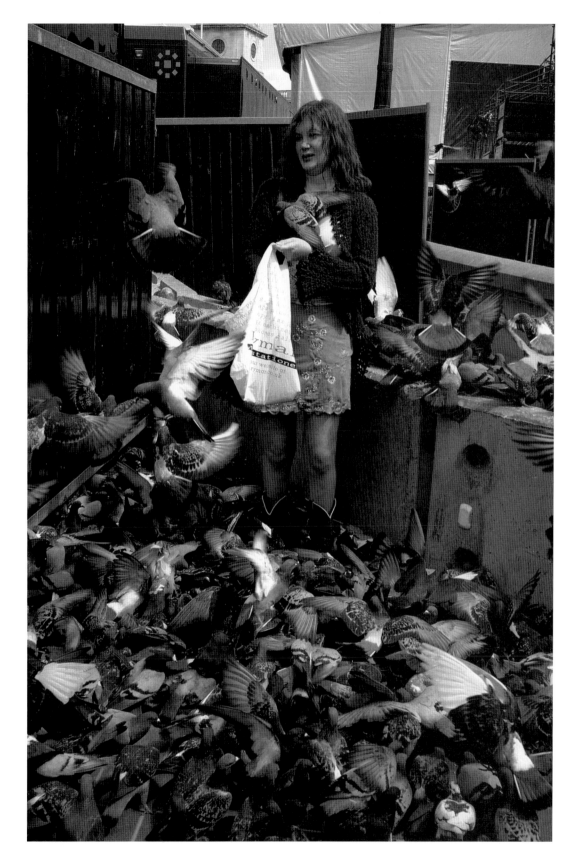

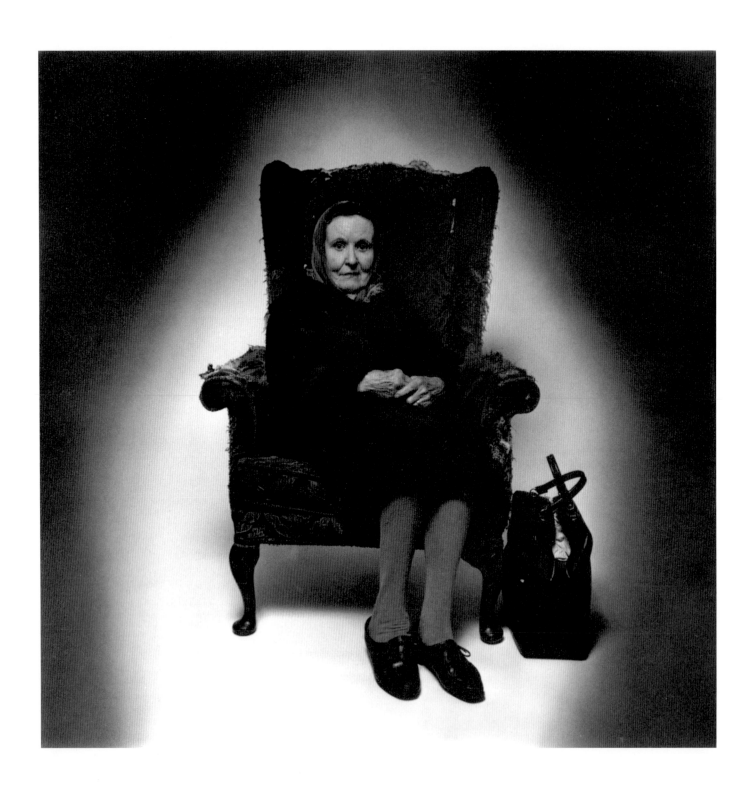

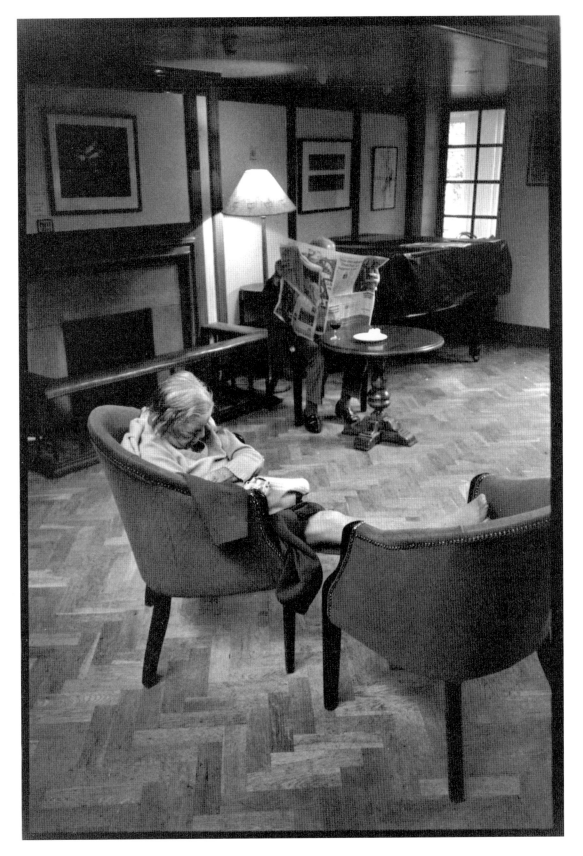

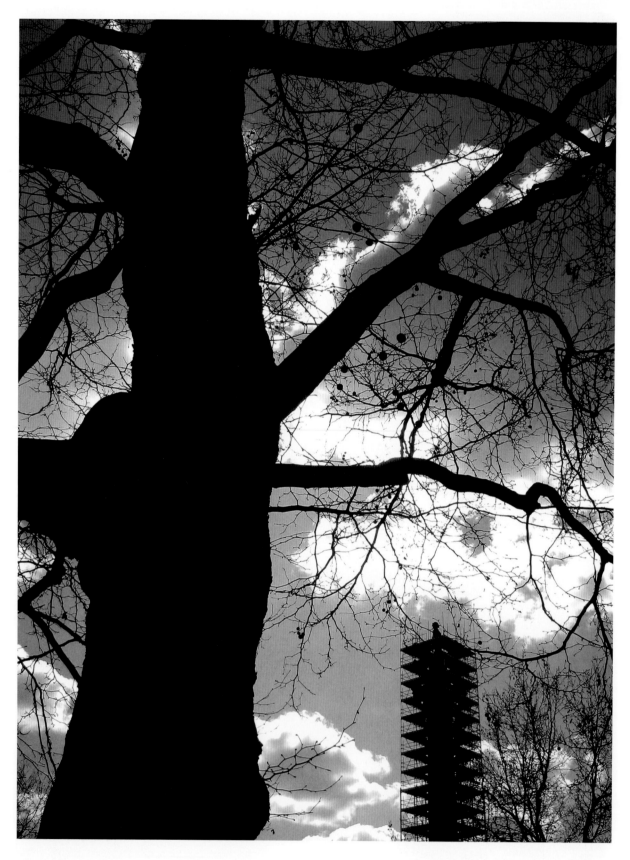

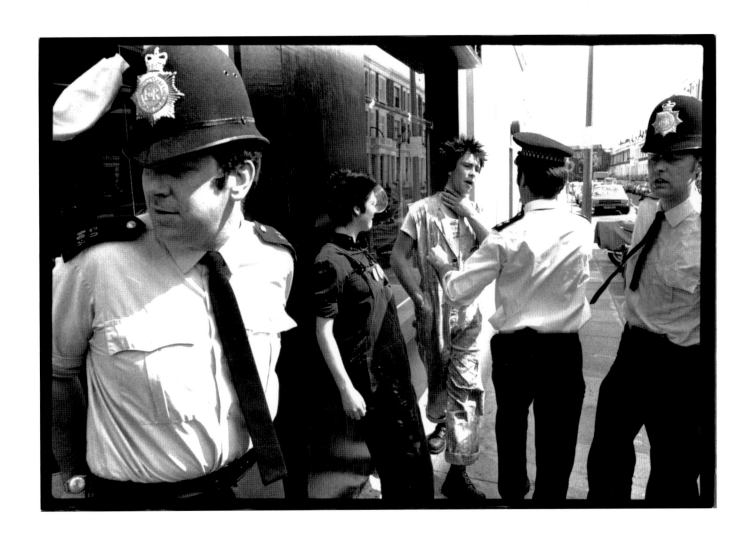

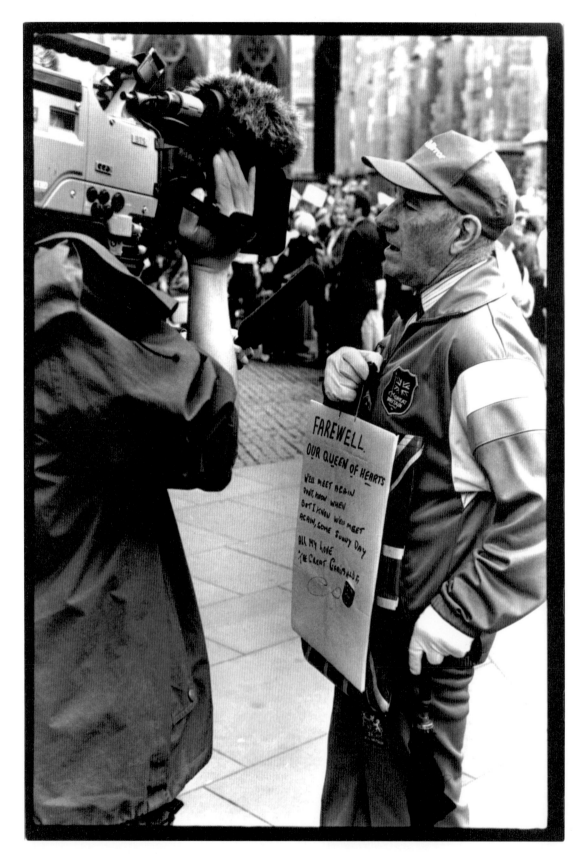

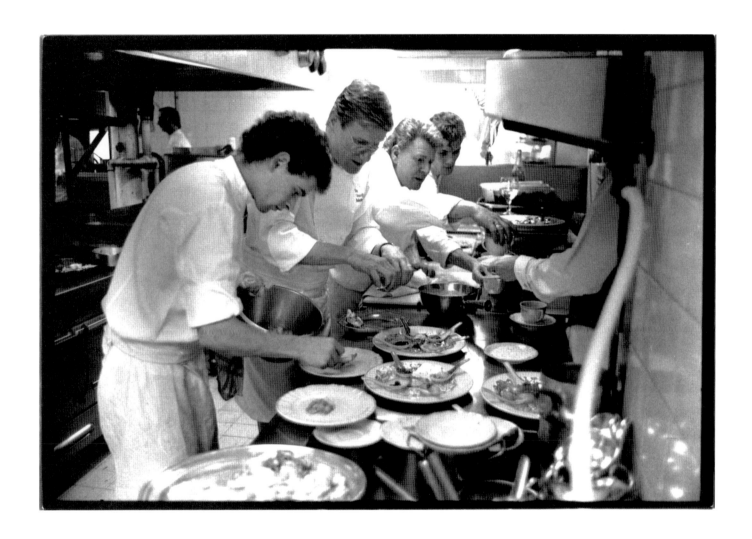

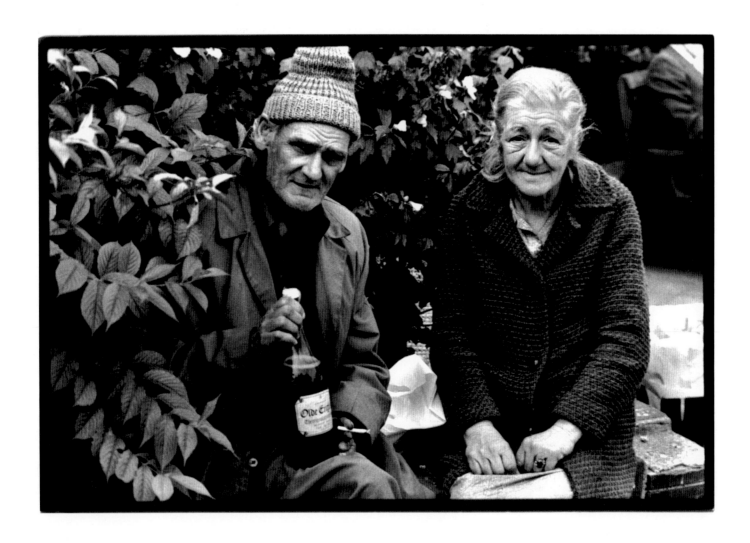

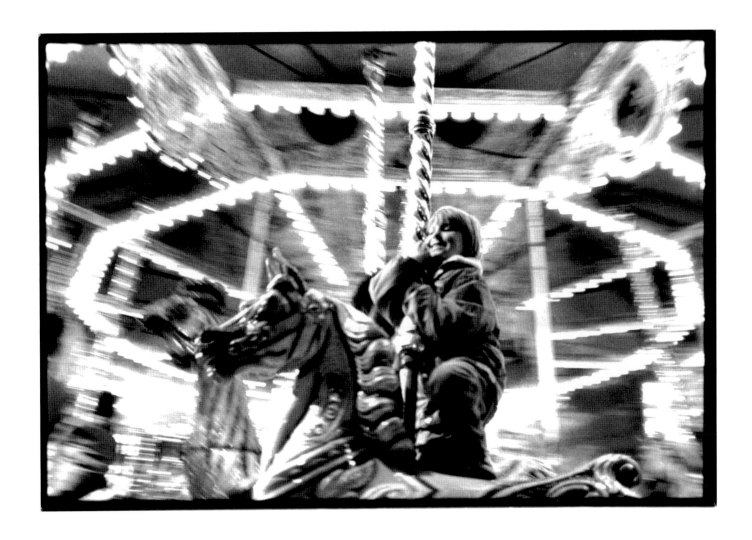

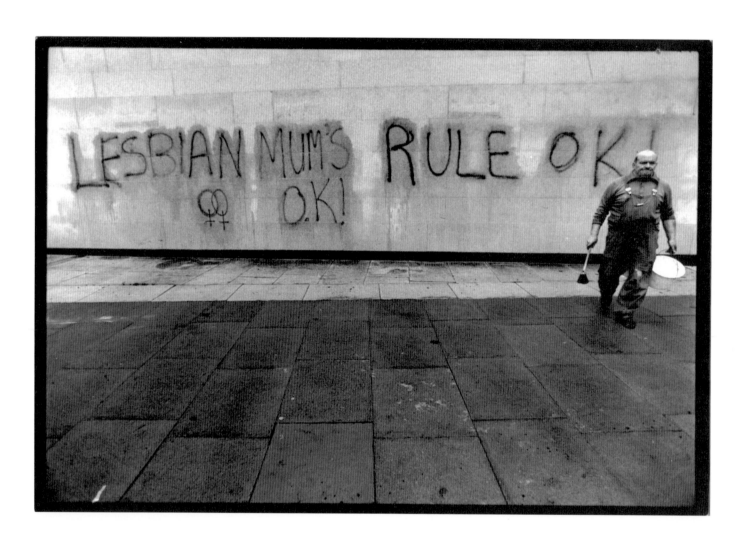

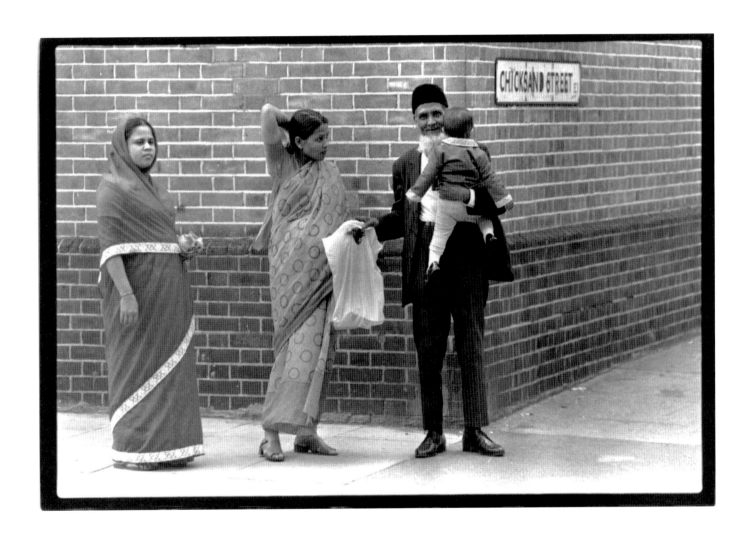

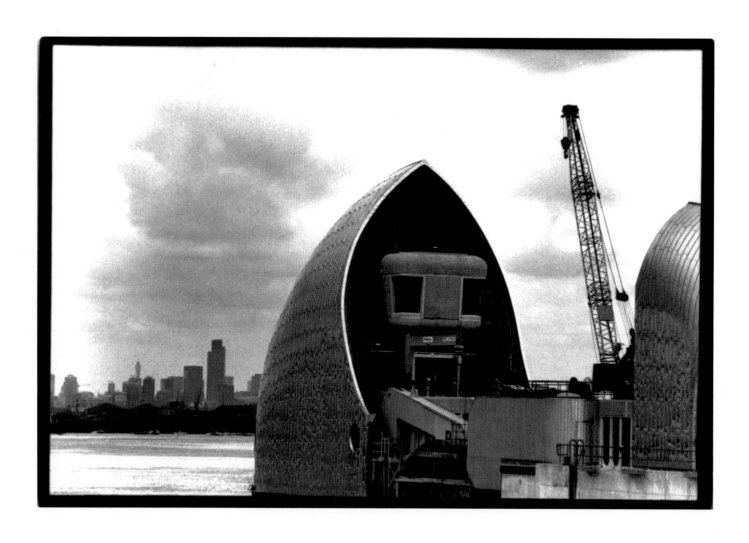

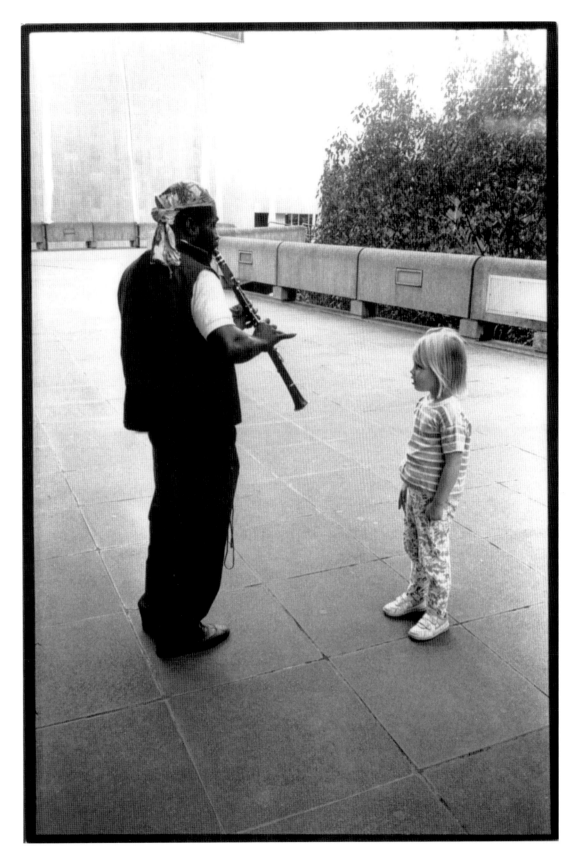

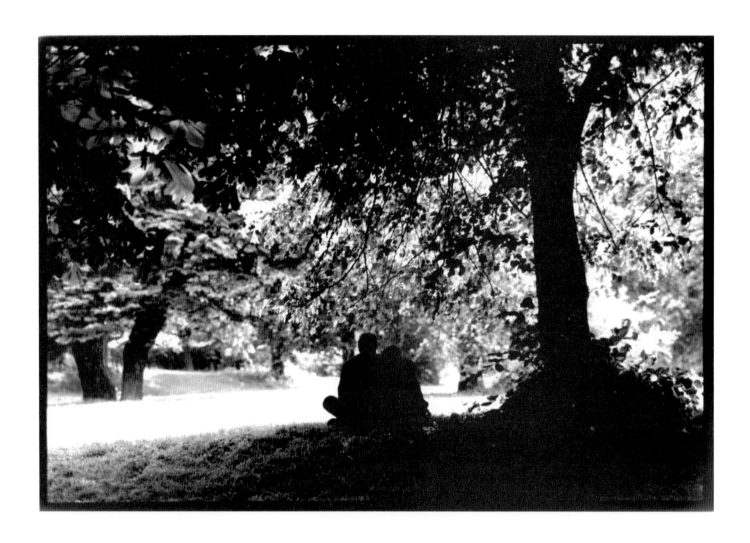

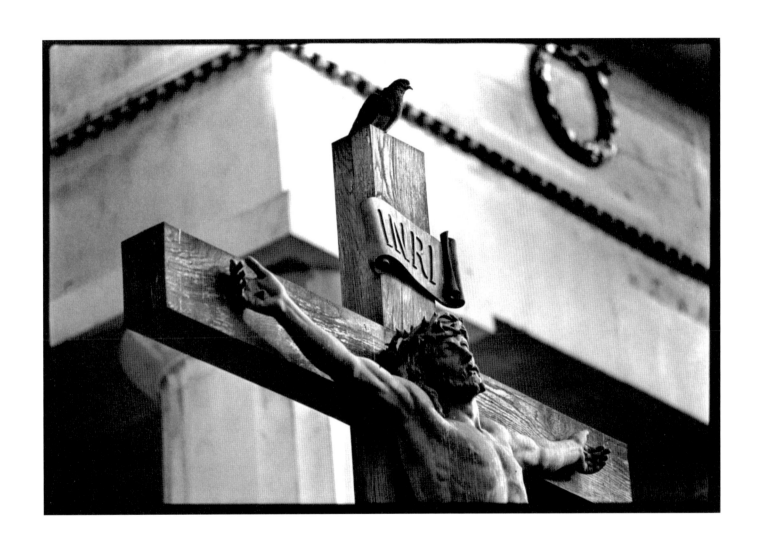

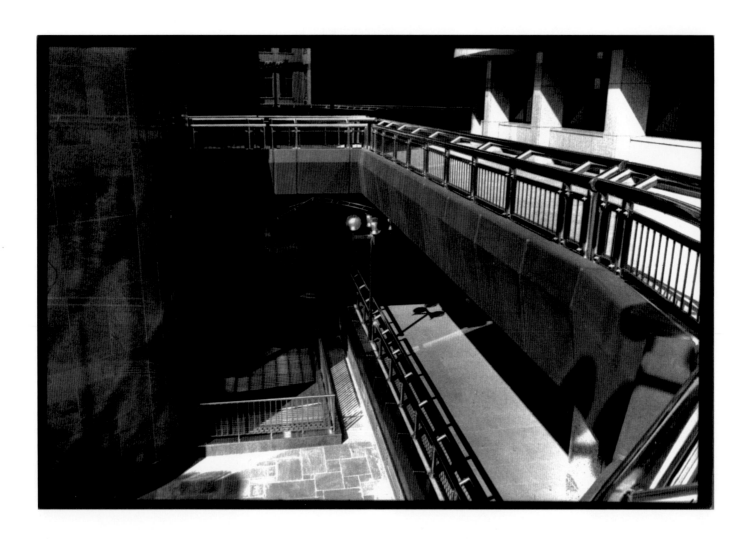

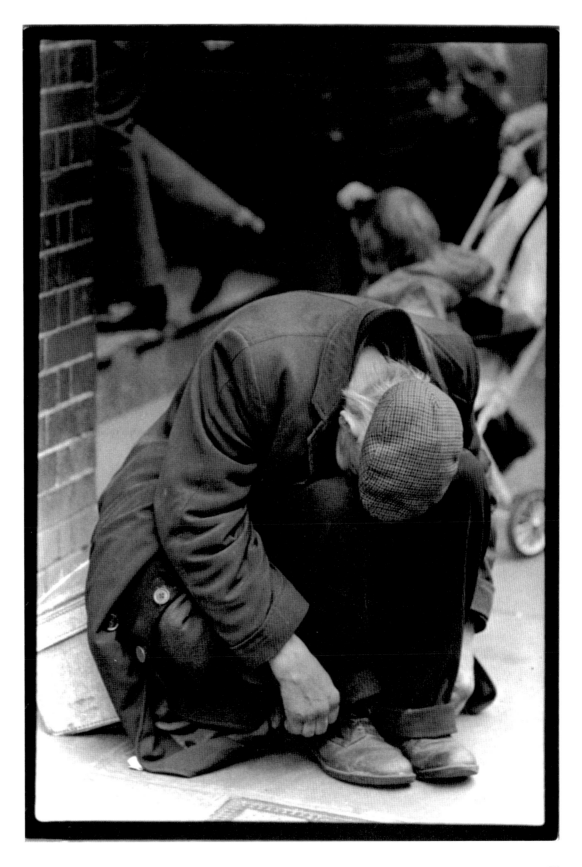

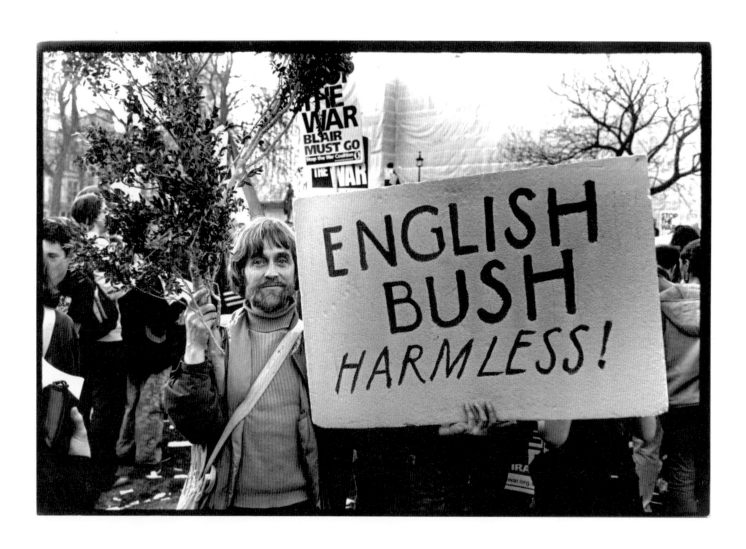

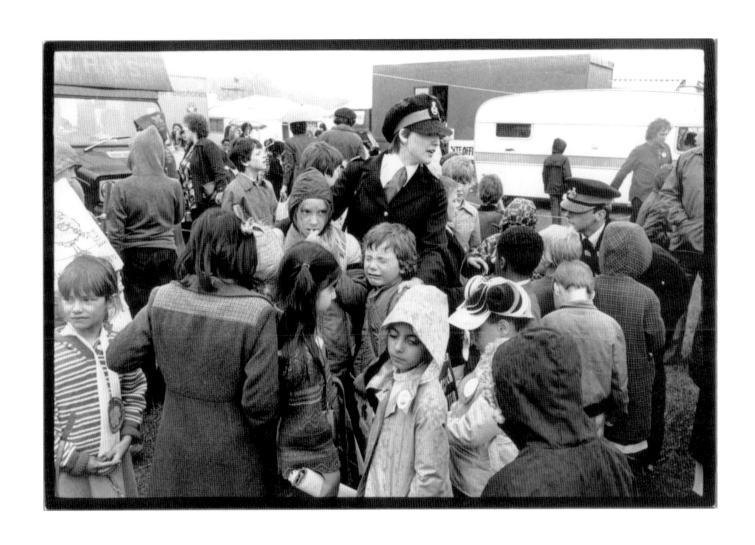

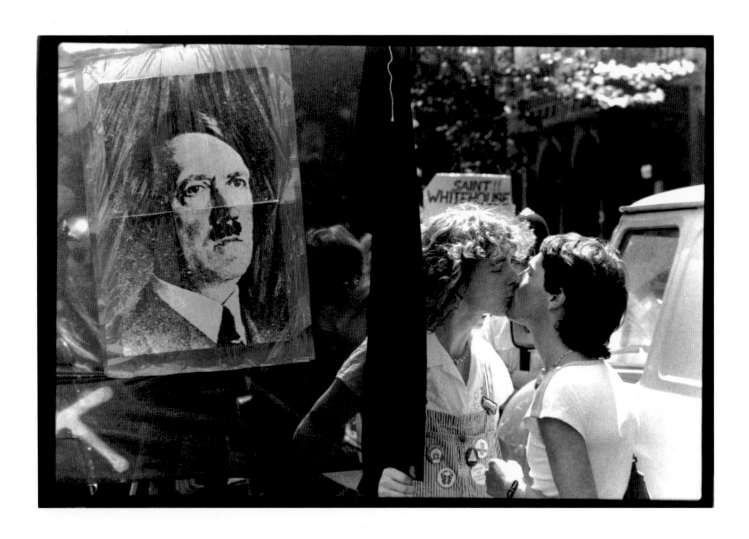

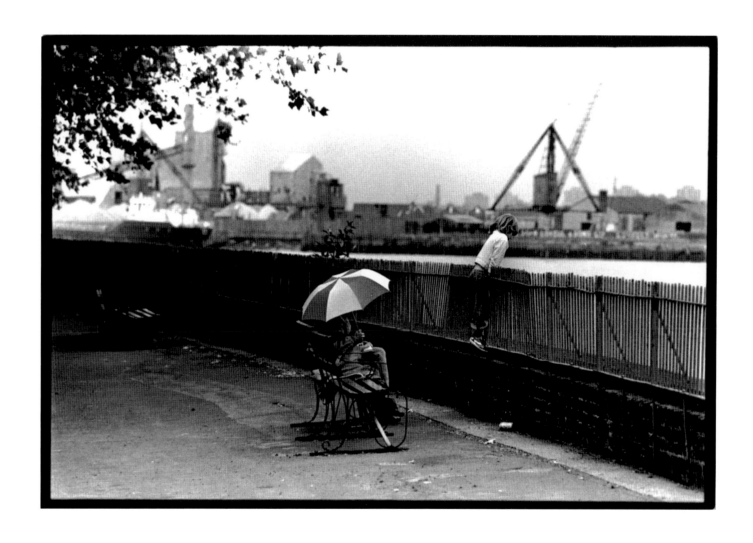

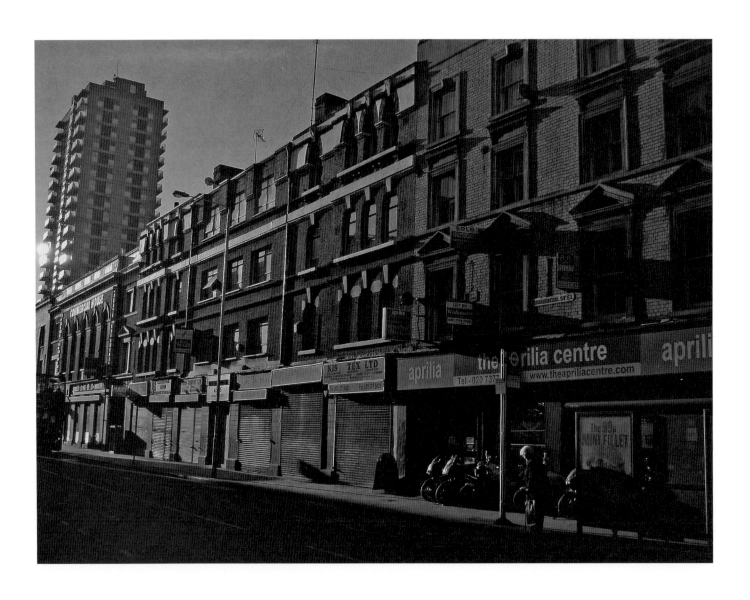

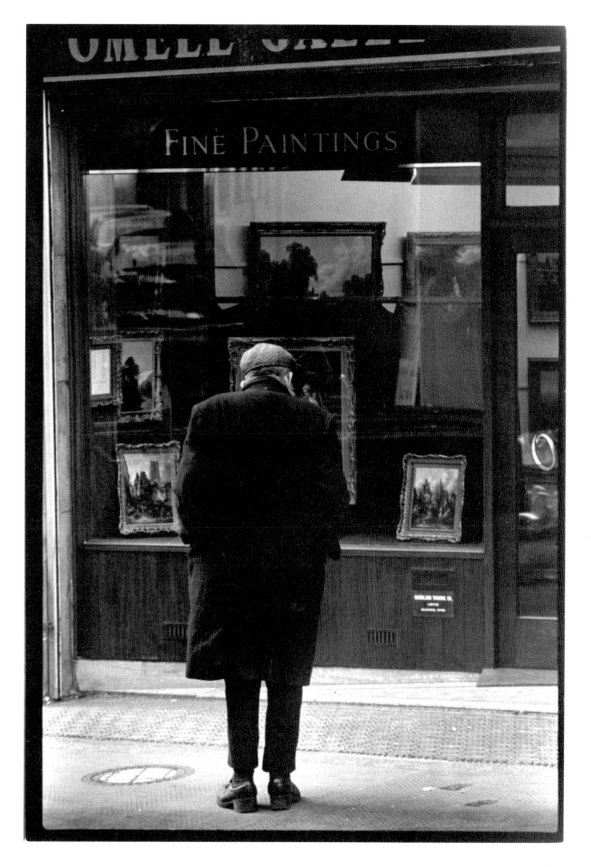

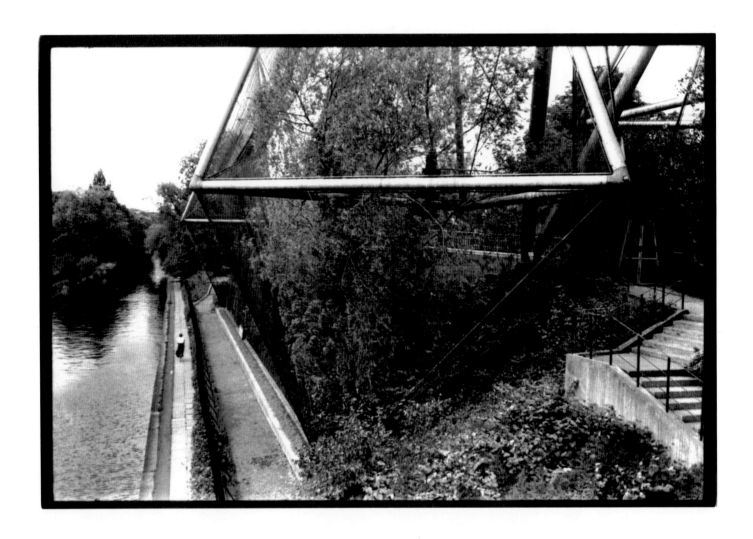

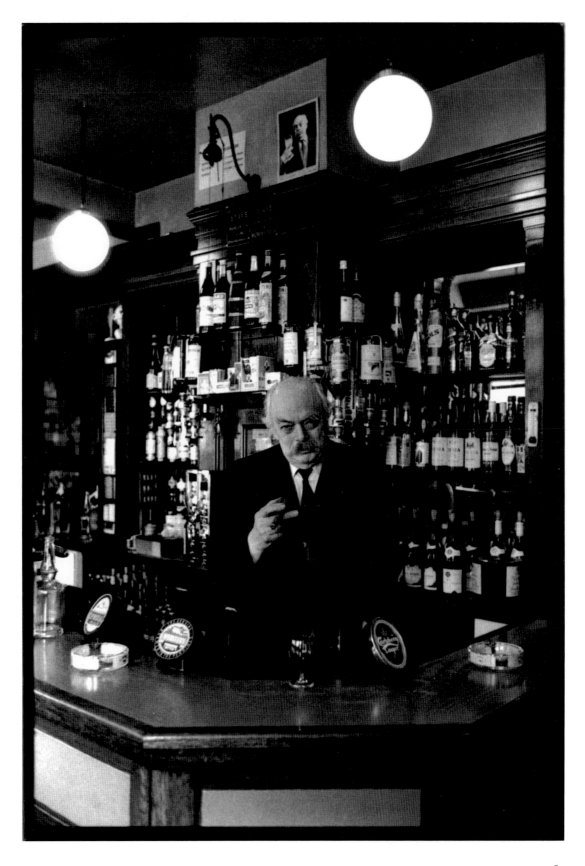

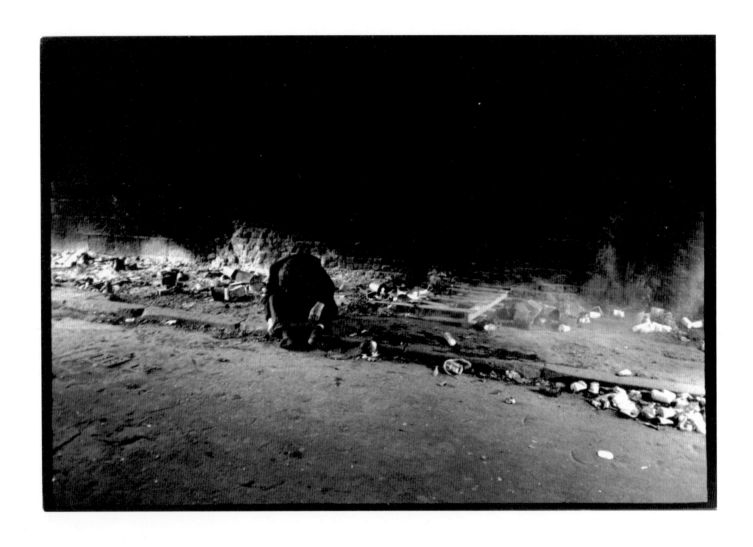

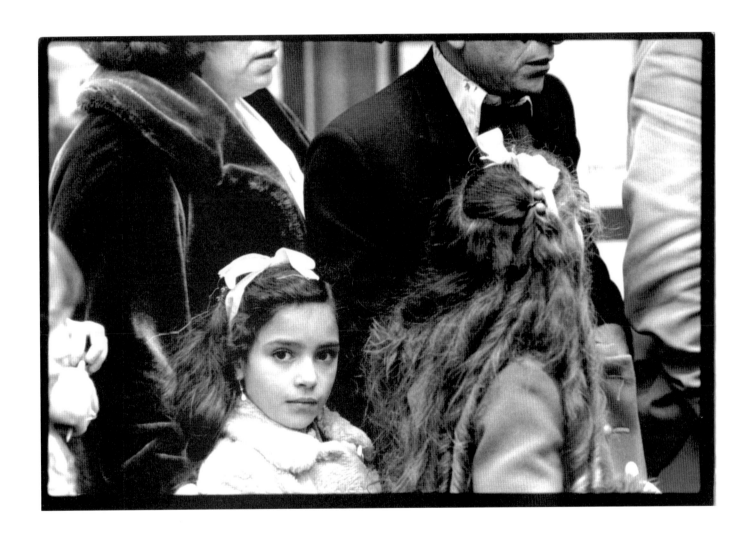

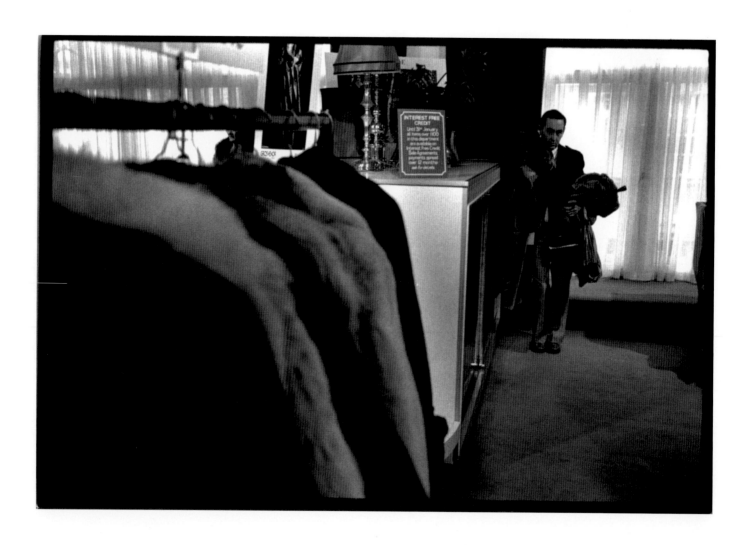

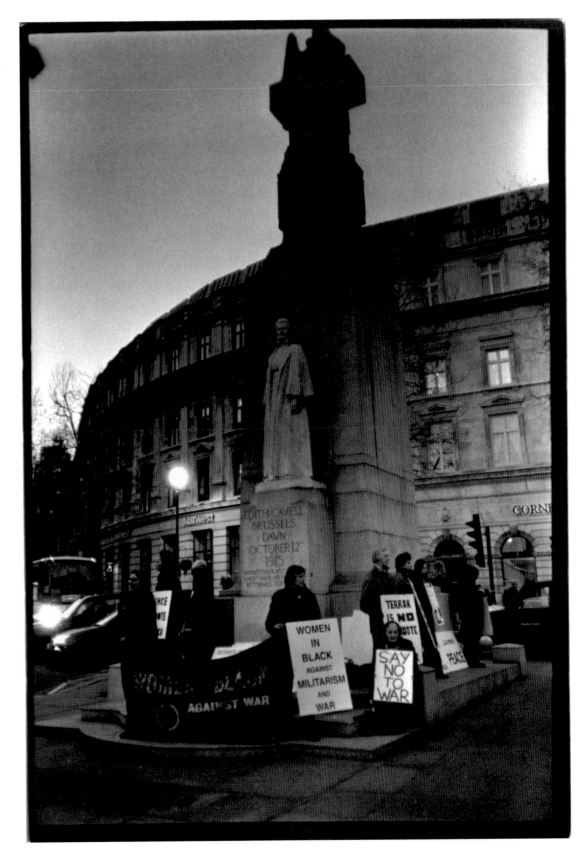

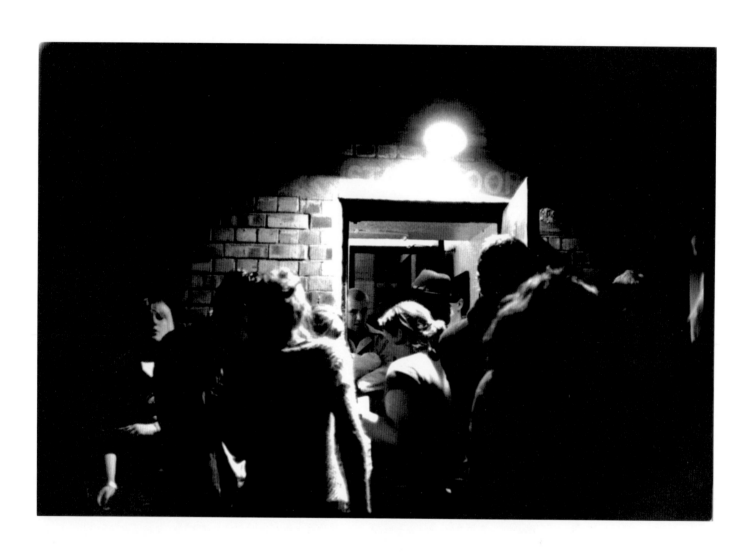

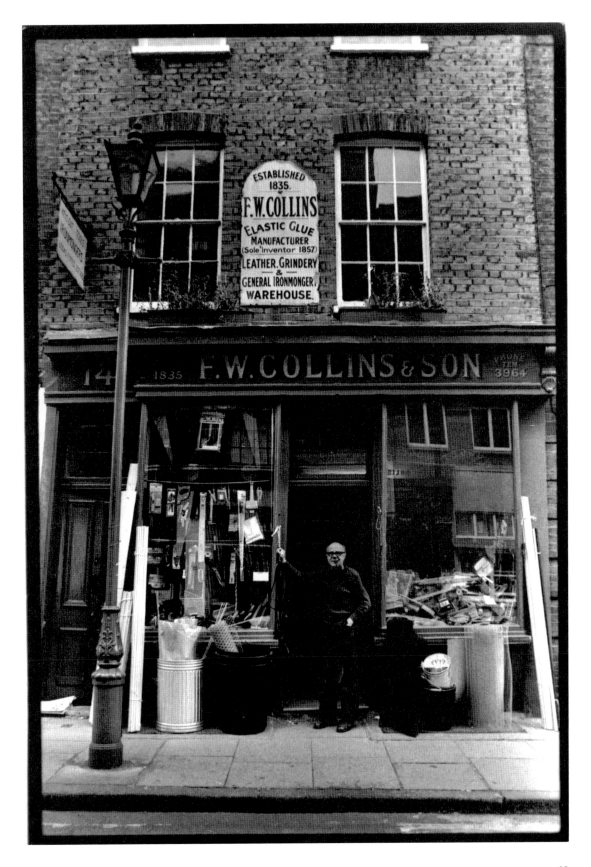

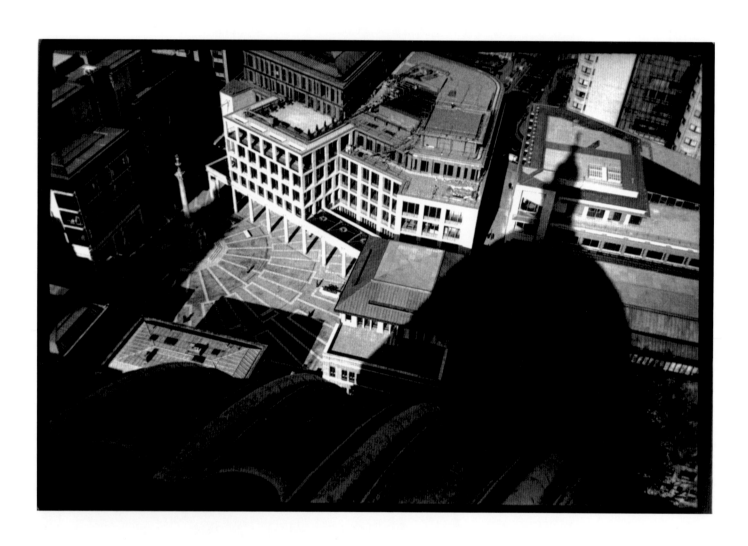

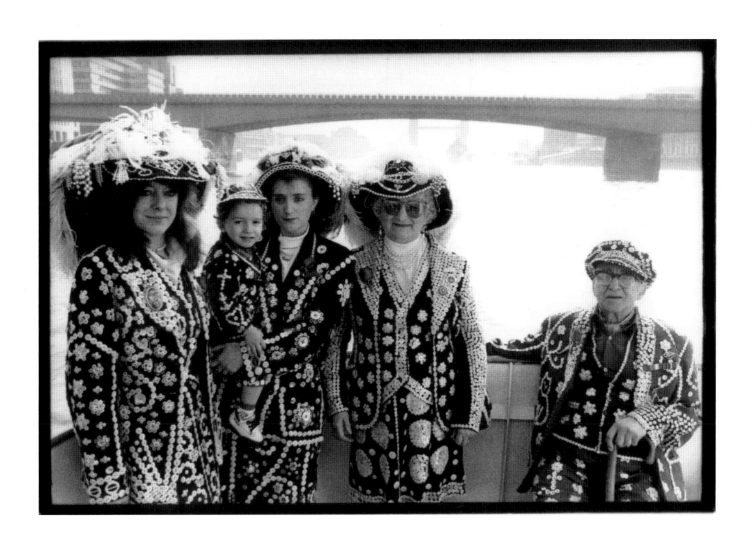

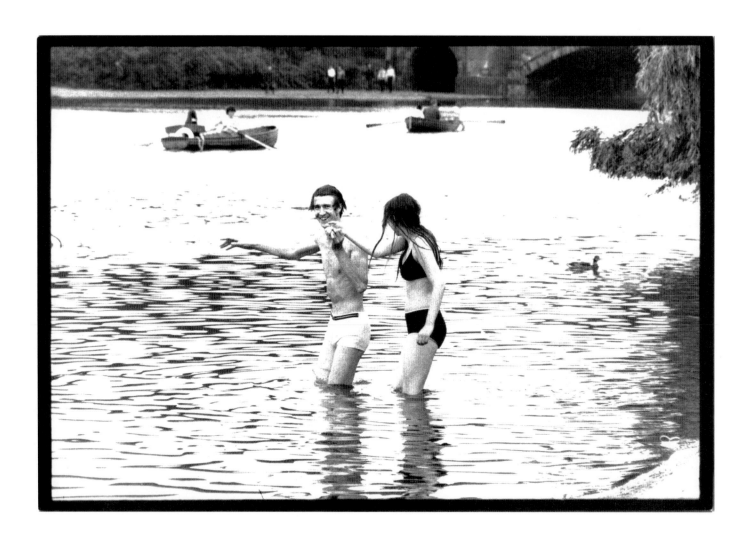

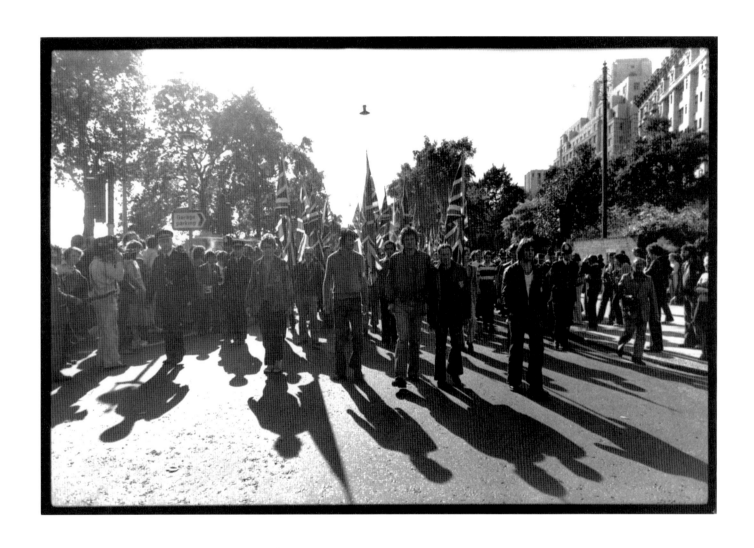

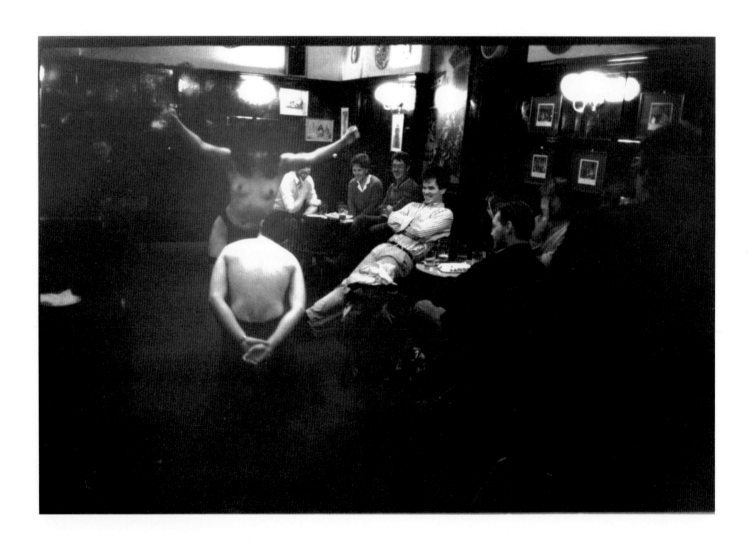

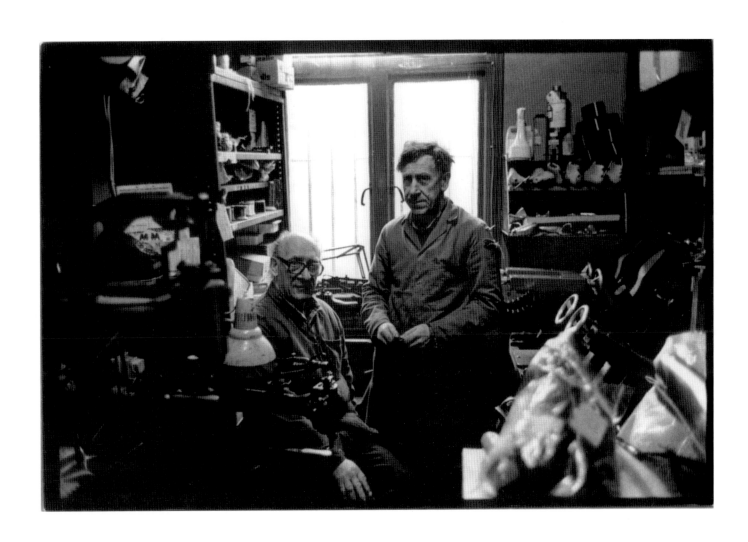

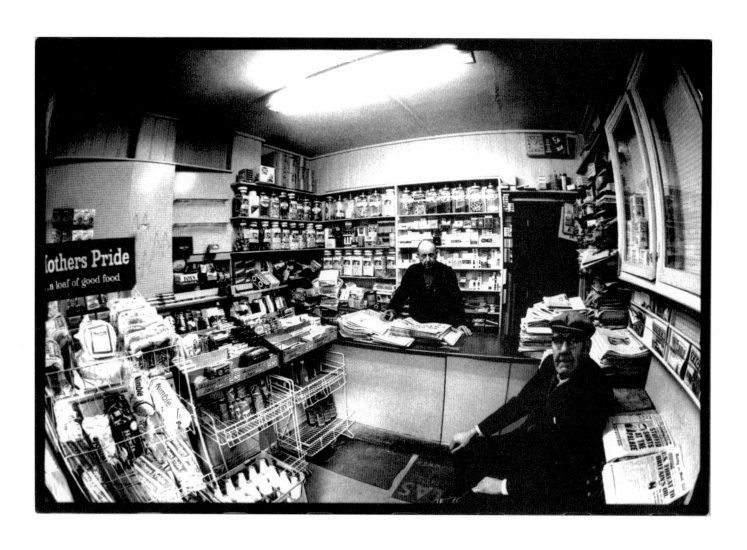

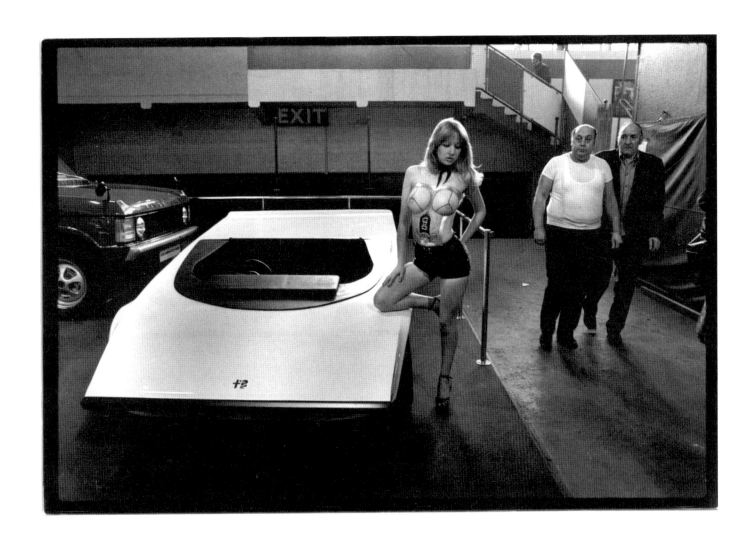

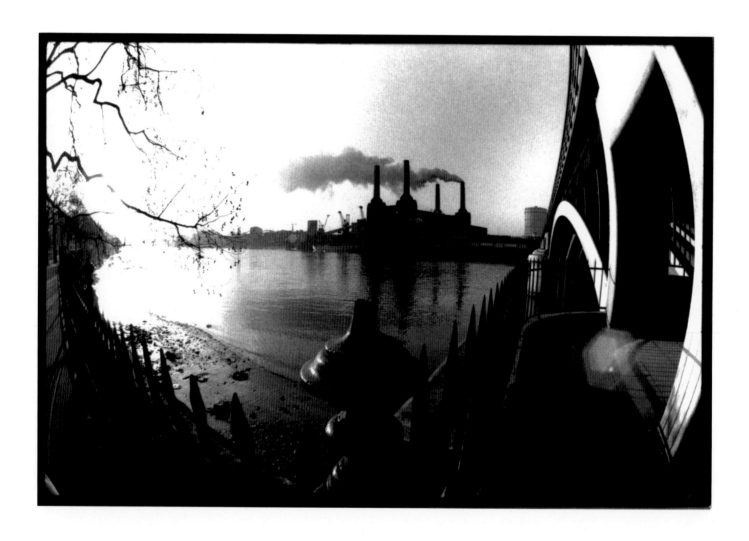

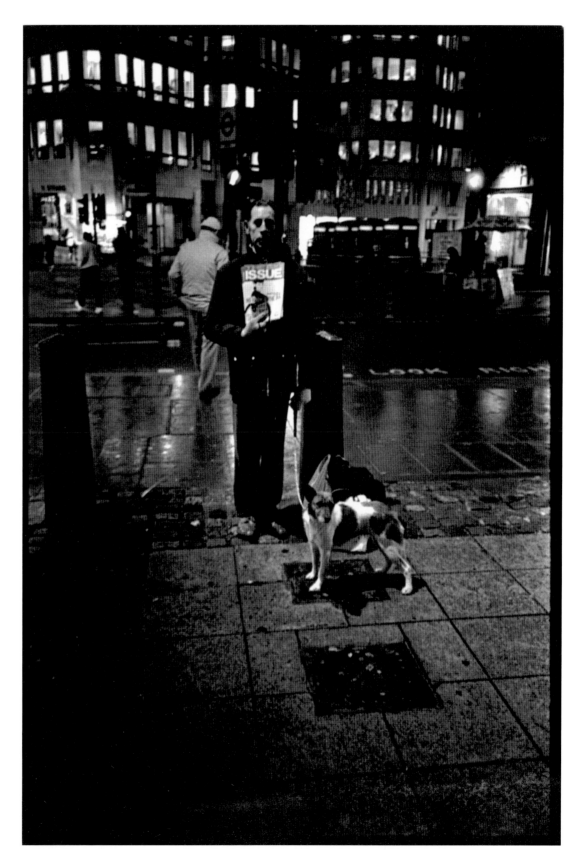

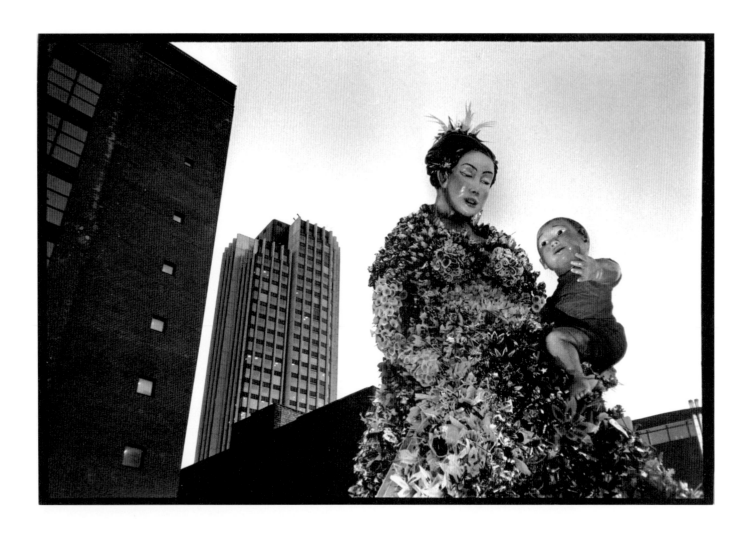

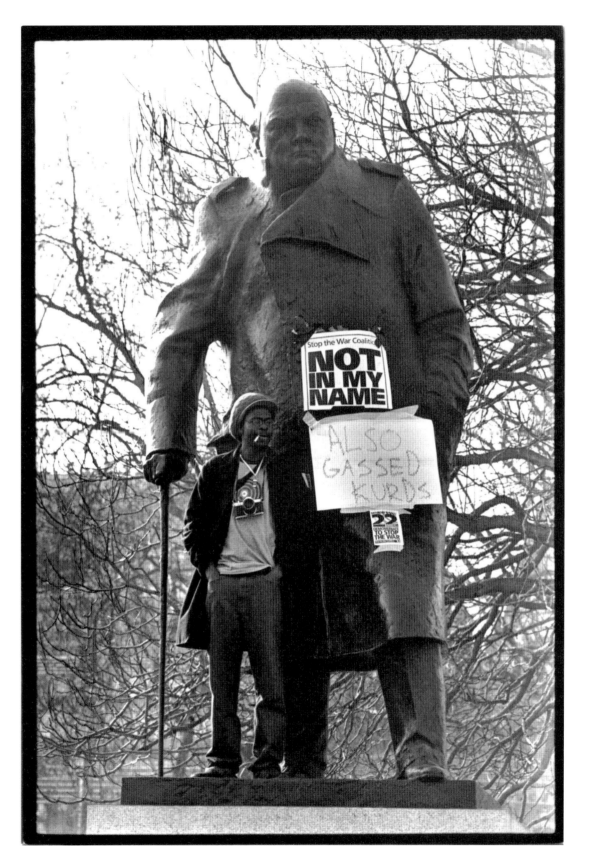

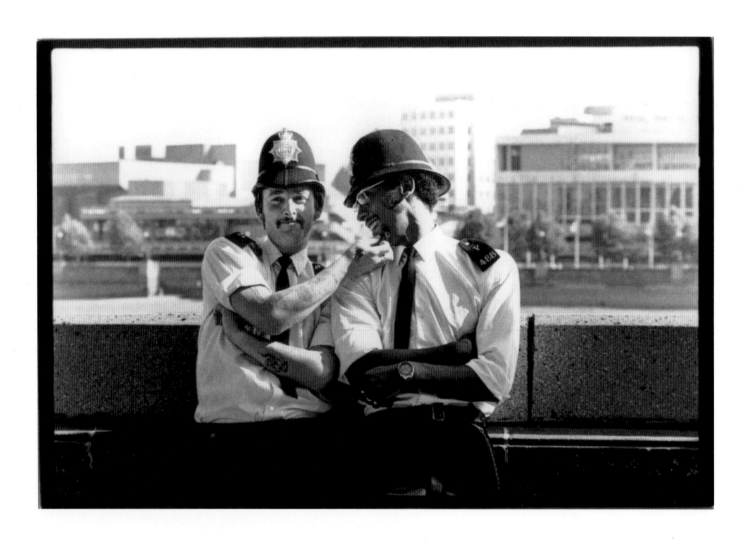

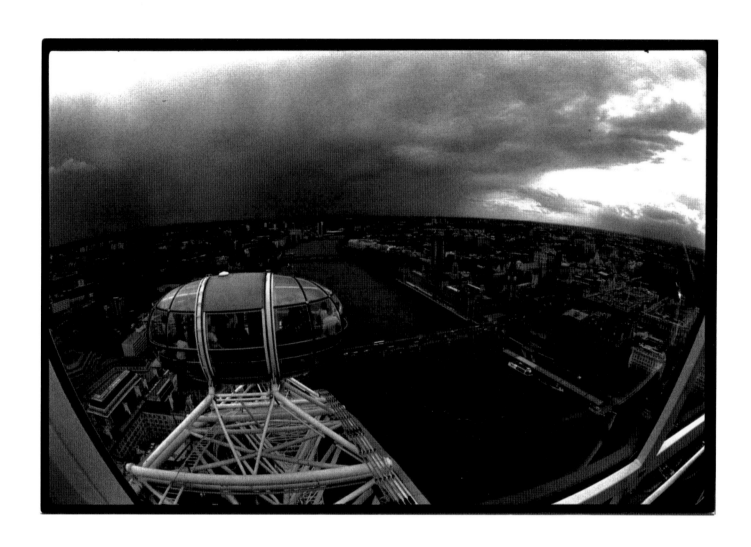

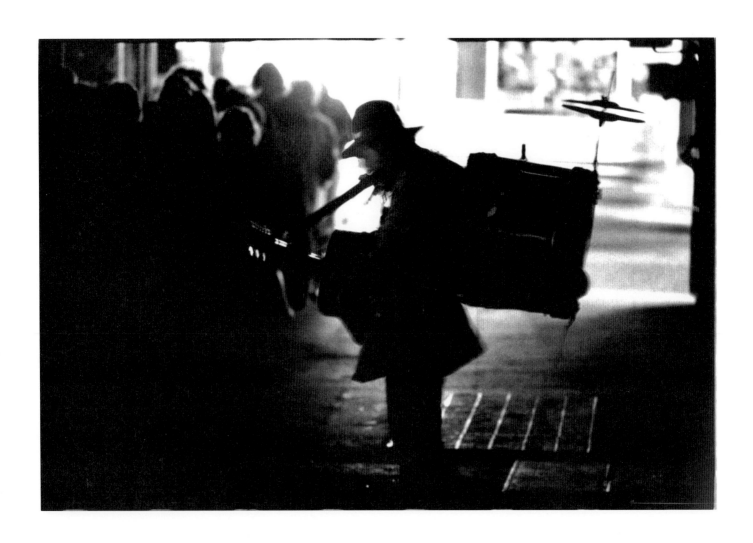

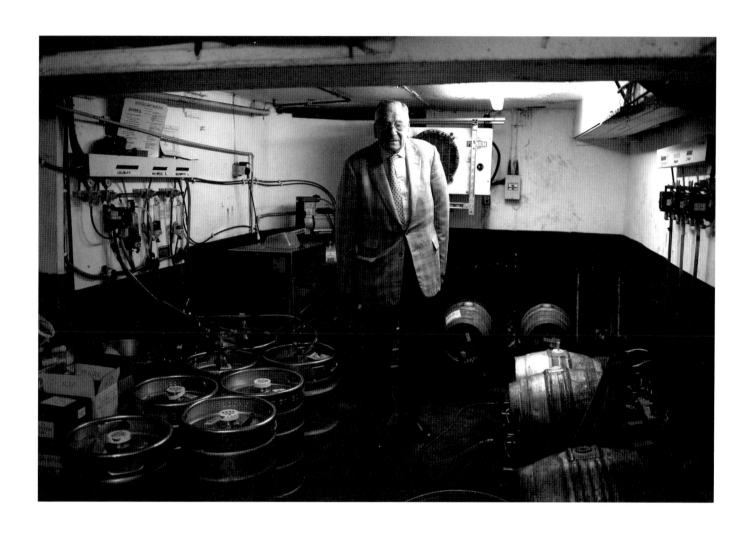

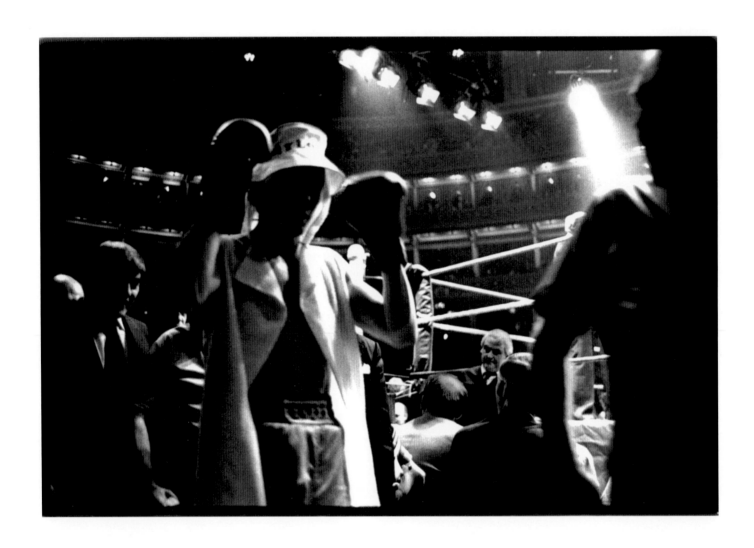

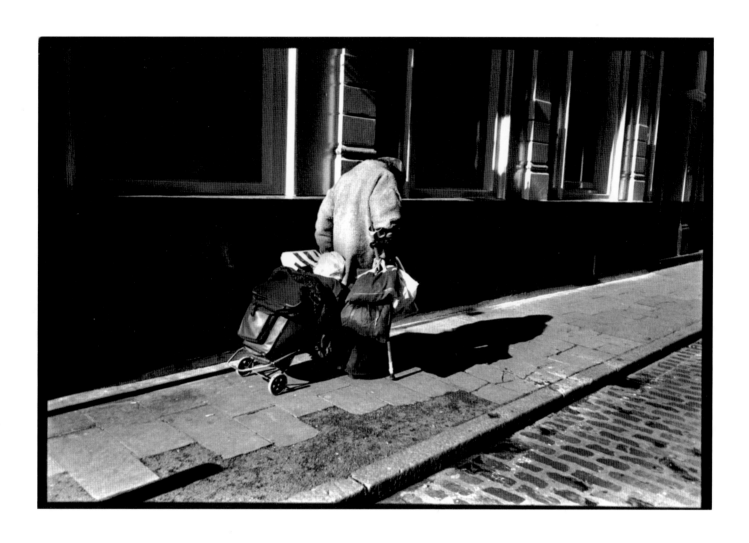